A PHILOSOPHY OF COMPUTER ART

What is computer art? Do the concepts we usually employ to think about art, such as 'meaning', 'form' or 'expression' apply to computer art?

A Philosophy of Computer Art is the first book to explore these questions. Dominic Lopes argues that computer art challenges some of the basic tenets of traditional ways of thinking about and making art, and that to understand computer art we need to place particular emphasis on the ideas of 'interactivity' and the 'user'. Drawing on a wealth of examples he also explains how the roles of the computer artist and computer art user distinguish them from makers and spectators of the traditional arts, and argues that computer art allows us to understand better the role of technology as an art medium.

Dominic McIver Lopes is Associate Dean in the Faculty of Arts and Distinguished University Scholar and Professor in the Department of Philosophy at the University of British Columbia. He is the author of two books on the philosophy of art, and editor (with Berys Gaut) of *The Routledge Companion to Aesthetics*.

A PHILOSOPHY OF COMPUTER ART

Dominic McIver Lopes

Routledge
Taylor & Francis Group

LONDON AND NEW YORK

This edition published 2010
by Routledge
2 Park Square, Milton Park, Abingdon, Oxon, OX14 4RN

Simultaneously published in the USA and Canada
by Routledge
711 Third Avenue, New York, NY 10017

Routledge is an imprint of the Taylor & Francis Group, an informa business

© 2010 Dominic McIver Lopes

Typeset in Joanna and Scala Sans
by Bookcraft Ltd, Stroud, Gloucestershire

British Library Cataloguing in Publication Data
A catalogue record for this book is available from the British Library

Library of Congress Cataloging in Publication Data
A catalog record for this book has been requested

ISBN10: 0-415-54761-X (hbk)
ISBN10: 0-415-54762-8 (pbk)
ISBN10: 0-203-87234-2 (ebk)

ISBN13: 978-0-415-54761-1 (hbk)
ISBN13: 978-0-415-54762-8 (pbk)
ISBN13: 978-0-203-87234-5 (ebk)

For

Damian Lopes

CONTENTS

ILLUSTRATIONS

PREFACE

A philosophy of computer art? If you need an answer to this question before spending any more time on this book, then chances are you're not sure about either the "philosophy" or the "computer art" sides of the question. The next seven chapters are designed to offer something to fans and students of computer art who are curious about what a little philosophy can do for them and also to philosophers who suspect that they can learn something about art in general from computer art.

I belong to the first generation to have grown up viewing computers as perfectly ordinary, unremarkable elements of everyday life. Though I blush to admit it, my first watch came with a digital display, I never used a slide rule, and, as a child, I acquired my first computer, an Apple II hooked up to an old TV set and a cassette tape player for memory. Since then I've monkeyed around with computers, mostly for fun, even as I first studied and then wrote and taught philosophy of art.

While I was always aware of art made by computer, this art never caught my fancy. Fractal images and early computer music, to take two examples, seemed one-dimensional as art, and simply didn't hold a candle to other computer products – games in particular. All this changed when I encountered works like the ones that will be introduced in chapters 1 and 2. These works struck me not only as very engaging but also as truly taking advantage of the power of computers – not just using them to do what could

already be done with older technologies. As I soon realized, some of these works also challenged certain tenets of my schooling in philosophy of art, and I came to see that my appreciation of them was enriched by thinking about them from a philosopher's point of view.

Fans (and scholars) of computer art inevitably end up doing a little philosophy on the fly. The novelty of computer art raises questions about what concepts we should use to engage with and study it. Concepts like "art," "work," and "meaning" are applied in encounters with any kind of art, from lounge music to postmodern novels, but it's normal to apply these concepts uncritically, without considering whether they're the right ones. When it comes to computer art, it's hard to avoid asking whether the concepts we bring to the table are fitting. So first encounters with computer art tend to be critical encounters. Through them we actively build up the appreciative practices that will eventually normalize one or another conceptual framework. Fans and scholars of computer art are philosophers perforce. No wonder the writings of computer artists, critics, and scholars are shot through with philosophical ideas. We'll look at some of these later.

In the circumstances, professional philosophy should have something to offer. A philosophy of computer art should set out a small number of propositions that are rigorously formulated and systematically connected. They're rigorously formulated if they pull together concepts, each of which is analyzed. Examples of key concepts analyzed in this book are "interactivity" (chapter 3) and "user" (chapter 5). They're systematically connected if some entail others or if together they entail further propositions that are true. A word of warning. Taken on their own, philosophical propositions often seem blindingly obvious. Therefore, they shouldn't be taken on their own: their power comes from their connections to each other. A philosophy of computer art should pay off by articulating a framework that illuminates our encounters with computer art.

A different payoff is needed for philosophers who ask "why computer art?" Here are two. (The next two paragraphs are the only parts of this book that indulge in explicit philosophy shop talk.)

Computer art is relatively new to philosophers, who've written fewer than half a dozen papers on the subject. That's an opportunity to craft an account of an art form, complete in all its main components. Chapters 2 and 3 propound a definition of computer art. Chapter 4 provides an ontology. Chapter 5 characterizes the roles of the computer artist and the computer art user, distinguishing them from makers and spectators of traditional art. Chapters 2 and 6 sketch out an aesthetics of computer art. Chapter 7

considers computer art's status as art. Not every possible topic is addressed, but the main ones are, and they're taken up together with an eye to the implications of each for the others. Such an enterprise is far too ambitious for arts, like music and literature, where it's necessary to contend with vast literatures. Noël Carroll's *Philosophy of Mass Art* does something similar for mass art – and his book is in some respects a model for this one.[1] The point is not that piecemeal approaches to the traditional arts are deficient. They're the best we can do. However, we can learn from comprehensive accounts of the lesser-studied arts how better to approach the traditional arts piecemeal.

In other words, computer art suggests new approaches to some familiar issues in the philosophy of art. One approach is how to understand the role of technology as an art medium that defines an art form. The doctrine of medium specificity, according to which each art form has a unique medium, has come under attack in recent years. If the definition of computer art defended here is right, then some art forms are definable with reference to media. Another familiar issue is the ontology of art. Chapter 4 doesn't take sides in the contemporary debate between Platonism and contextualism, but it does develop some ideas about when works have multiple instances. A third issue is rather neglected in contemporary philosophy – theories of art-making, performing, and spectating. Computer art requires some rethinking of these activities and the roles associated with them.

Some of this rethinking may be useful to non-philosophers who study computer art, for it challenges foundational assumptions of that scholarship. One assumption identifies computer art with digital art. Without a doubt, computers have changed art and the practice of art because they deal in digitally encoded information. However, they also run algorithms or computational processes, and this opens up possibilities for a new kind of art, indeed a new art form. This book focusses on this new kind of art. To dramatize the point, the book ends with a look at video games as examples of computer art. If video games are computer art and yet we find their art status hard to swallow, then taking video games seriously challenges how we think about computer art and indeed about all art.

The first philosophy paper on computers and art dates back to 1961.[2] As soon as people could get their hands on the technology, they used it to make art, and that art was seen as a special opportunity to think about art. As we run up to the fiftieth anniversary of that first philosophy paper, perhaps it's time to look more closely into the philosophical opportunities posed by this new art form.

ACKNOWLEDGEMENTS

In a book about computer art, why not skirt the bounds of nerdiness and credit those responsible for creating the technology that eased my research and writing? A complete list would be very long. I'll single out the makers of Pages for word processing, BBEdit for reading code, QuickTime and VLC for viewing video, Safari and Camino for reading web pages, WordNet for finding words and their meanings, Seashore and Gimp for editing raster images, Inkscape for editing vector images, and OS X and its BSD underpinnings for keeping everything running without a hitch.

Turning from computational to financial and human support, I also thank the Social Sciences and Humanities Research Council of Canada and the Peter Wall Institute for Advanced Studies for backing this project. I began writing the book during a year's visit to the Peter Wall Institute, and I'm especially grateful to the staff and scholars at the Wall for their encouragement and camaraderie. Friends, colleagues, and students who previewed parts of the book made so many useful suggestions that it would be embarrassing to display them in footnotes. My gratitude goes to Vincent Bergeron, Aili Bresnahan, Tony Bruce, Berys Gaut, Susan Herrington, Jenn Neilson, Dustin Stokes, Routledge's referees, and members of audiences at the American Society for Aesthetics, Kansas

State University, the University of British Columbia, and the University of Sussex.

All but the first and final chapters of the manuscript were put to the test in Philosophy 339, which met in Room 100 of UBC's Math Building through the fall of 2007. My co-instructor, Josh Johnston, taught a draft of the book with flair and clarity, and I tried my best to answer difficult questions and objections from him and members of the class. My thanks to Rose Bouthillier, Derrick Denholm, Hong Bo Diao, Stephanie Krasnow, Thomas Vogel, and Amy Zion for ideas that substantially improved the final draft. A special thanks also to Amy Zion for permission to reproduce figure 4.1, the winning entry in the Philosophy 339 Refrigerator Magnet Poetry Contest.

Photo credits

Figures 1.1, 3.1, 3.2, 4.1, 5.1, 5.2, 5.3, 7.1, 7.2, and 7.4 have been released by their creators to the public domain or have been published under the Creative Commons License or the GNU General Public License. Figure 1.2 photo credit: (CC) Dean Ayres, http://www.flickr.com/photos/deano. Figure 1.3 by permission of Jim Andrews. Figure 1.4 courtesy of Stelarc. Photo by Igor Skafar. Figure 1.5 © Andreas Gursky/SODRAC (2008). Photo credit: CNAC/MNAM/Dist. Réunion des Musées Nationaux/Art Resource, NY. Figure 1.6 photo credit: (CC) Sebastià Giralt, http://www.flickr.com/photos/sebastiagiralt. Figure 1.7 courtesy of Harold Cohen. Figures 2.1 and 3.2 courtesy of Jeffrey Shaw. Figure 2.2 courtesy of Ken Goldberg. Figure 2.3 courtesy of Damian Lopes. Figure 2.4 courtesy of Scott Snibbe. Figure 3.4 photo credit: (CC) Katie Tegtmeyer, http://www.flickr.com/photos/katietegtmeyer. Figure 3.5 courtesy of Daniel Rozin. Figure 3.6 photo credit: York Wegerhoff, http://www.flickr.com/photos/yorkwegerhoff/sets. Figure 4.1 courtesy of Amy Zion. Figure 5.4 by permission of Camille Utterback and Romy Archituv. Figure 6.1 courtesy of Lynn Hershman. Figure 7.3 courtesy of Thomson and Craighead.

Many of the works discussed in this book can be viewed in full motion or in color at http://apoca.mentalpaint.net.

1

THE MACHINE IN THE GHOST

The idea becomes a machine that makes the art.

Sol LeWitt

Few generations in all of human history have been lucky enough to witness the birth of a new art form. Architecture and landscape architecture are as old as building and organized land use. Visual art dates at least to the painting of the caves at Chauvet, France some thirty to forty thousand years ago. Around that time, humans crafted the earliest known musical instruments, and dance probably went with music. No trace remains of Paleolithic verse or theater, but it stands to reason that they followed close upon the heels of myth and ritual. Movies and photography are recent additions to the ancient family of art. The newcomer is computer art, which is indeed so new that nobody really knows what it is and whether it's worth their time and attention. A philosophy of computer art can help by expressing the nature and value of this art form.

Digital art

This book's title announces its topic as "computer art" rather than "digital art," and the choice of words is deliberate. As I'll explain, computer art isn't

the same as digital art. Moreover, computer art is a new art form and digital art is not. Let's start by looking at digital art.

Curators, critics, and scholars now routinely use the name "digital art" instead of "computer art." "Computer art" was the designation of choice thirty years ago when computers enjoyed considerable cachet as the latest, coolest technology. Most computers in those days filled whole floors of office buildings and could be seen only by a privileged few. By the eighties, mass-produced "personal computers" found their way into homes and offices, fitting in as part of the humdrum furniture of everyday life. In a word, they became appliances. Now "Compaq" and "Amstrad" hardly sound like they belong in the same sentence with "art." No wonder the contemporary art world prefers to speak of "digital art," "information art," or "new media art," and has dropped the old moniker, "computer art." As you read this book, I ask you to set aside any negative associations that cling to the name of "computer art" and that push us to prefer "digital art."

Digital art and computer art aren't the same because they take advantage of different aspects of computer technology. A good way to appreciate the role computers play in computer art is to contrast it with the role they play in digital art. In digital art, this role is relatively obvious, though it requires a very short technical interlude.

Computers store and process information in a common digital code. Every computer user is aware of this side of computers, which is drummed into us by marketers and educators. On a practical level, we use computers to write and archive text, send messages, mediate voice communications, touch up images and arrange them into albums, edit movies, compile play-lists, and crunch numbers. In researching this book, I read journal articles and books downloaded from online databases and I viewed images and video clips on my web browser (I also played a few games, as part of my "research" for the final chapter on video games). The text itself was written on a computer, which took responsibility for spelling and formatting. Some illustrations were scanned or downloaded and then modified in an image editor; others were made from scratch using drawing software. The manu-script was sent to a copy-editor by email, who put everything in shape for the designer, who set the type electronically. Printing, binding, sales, and shipping were all handled by computers. As icing on the cake, you might be reading the final product in e-book format. The point is that computers are so useful partly because they're *all-purpose representation devices*. They deal with information in many different formats – text, numbers, images, sounds – by converting them all into a common, digital code.

Digital codes are made up of discrete and discontinuous elements. Most electronic computers use binary code (represented as zeros and ones). The Wikipedia article about the ENIAC computer built in 1946 at the University of Pennsylvania contains a description and images of the machine, and all of these are ultimately stored and transmitted in the same binary code. However, binary isn't the only digital code. The alphabet is another digital code, and so are Arabic and Roman numerals, traffic signs, and semaphore, to mention a few examples. None of these are binary, but all are digital, since they're made up of discrete and discontinuous elements (such as letters, numerals, conventionalized icons, and flag patterns). And while most digital computers use binary for engineering reasons, it's possible to build computers that operate with other digital codes. What matters here is that each computer deals with *all* information by formatting it in the same *digital code.*

Digital art includes movies, images, music, stories, and other kinds of art that take advantage of a computer's ability to deal with them in a common, digital code. Emphasize *common* digital code. Also emphasize: encoded by a *computer.* Trick question: was there any digitally-encoded art before the invention of the electronic computer? Answer: yes! *A Midsummer Night's Dream* is digitally encoded, because it's written in the English alphabet, which is a digital code. Likewise, the *Well-tempered Clavier* is digitally encoded because standard musical notation is a digital code. Of course, Shakespeare's plays aren't digital art and Shakespeare wasn't a digital artist. Neither was Bach. The lesson is that there's more to digital art than digital encoding. Digital art involves *computer-based* encoding in a *common* digital code. A theory of digital art makes this explicit:

> an item is a work of digital art just in case (1) it's art (2) made by computer or (3) made for display by computer (4) in a common, digital code.

Some traditional art is encoded digitally, but it's not digital art because it doesn't fit this theory. Shakespeare's plays and Bach's compositions are digitally encoded, but they weren't made by computer or made for display by computer in a common digital code. As a result, they're not digital art.

This theory of digital art isn't intended to model how we normally use the words "digital art." It's meant to highlight a specific phenomenon, by contrast with other phenomena. The next chapter will distinguish digital art from computer art. For now, it's easy to see why we should distinguish digital art from information art and new media art. Not all information is

digitally encoded and computer-based. Hans Holbein's *Ambassadors* (fig. 3.2) conveys lots of information, but it's not digital art. According to one definition, new media art covers "projects that make use of emerging media technologies."[1] Some count video and even film photography as new media. Yet video and film aren't digital.[2] Why assume that every emerging technology uses digital encoding by computer? Those who speak of "digital art" often lump together these different phenomena under a single banner. A theory of digital art is a filter that brings out commonalities in one group of art works and that makes clear how these works differ from other kinds of art works.

Digital displays

The word "display," borrowed from computers, comes in handy to think about art. Every work of art includes some structured entity that results from the artist's creativity and that we tune into when we appreciate the work. Call this entity the work's "display." The display of a painting is a two-dimensional marked and colored surface. In dance, it's a rhythmic sequence of body movements through space. In music, it's a sequence of sounds characterized by tone, meter, and timbre. In novels, it's a sequence of sentences that tells a story. In general, a work's display is a structure that results from the artist's creativity and that we apprehend in order to grasp a work's meaning and aesthetic qualities. As clause (3) of the theory of digital art announces, some works of digital art are made for digital display.

As soon as computers were invented, engineers and artists began to adapt them to display works of art; and as personal computers shipped to homes and businesses, they were also adapted by their owners to display art. These beginnings were remarkably simple. For example, ASCII art turned to advantage a limitation of many early personal computers, which lacked a GUI (Graphical User Interface) and only displayed a set of characters (called the ASCII character set) in a fixed-width typeface. In ASCII art, these text characters are used to render images – sometimes images of text banners and signatures, like graffiti tags. ASCII art has aficionados, stretches to comics and animation, and falls into several recognizable styles – Amiga, Newskool, and ANSI, for example. Carsten Cumbrowski's Closed Society banner is a Newskool piece which illustrates a characteristic device of ASCII art – the interplay between the image and the choice of text used to render it (fig. 1.1). The $-sign has a double meaning – it evokes commerce or capitalism and it's also a standard computer programming notation for a variable that can be assigned any value.

Figure 1.1 Carsten Cumbrowski, Closed Society 2 Banner

Digital images built out of pixels have had an enormous impact on the visual arts during the past twenty years. Digital photography now dominates film photography, and movies recorded digitally and shown on a digital monitor or projector are increasingly common. The same goes for digital illustration and animation. As we'll see, some interesting features of digitally displayed images and movies have to do with how they're *made*. For now, it's worth considering a feature of the *display* of digital images.

Traditional images (e.g. paintings) are mostly physical objects: they're identical with their displays.[3] As a result, they can be shown in only one place at a time. True, multiple prints of photographs can be displayed in many places at the same time, but there remains a material limitation on their display – most photographs have a set number of prints made by the photographer. And while it's also true that reproductions of paintings and photographic prints can be distributed very widely (in books, postcards, posters, and calendars), a reproduction of a painting isn't the same as the painting and a reproduction of a photographic print isn't the same as the print.

By contrast, digital images are transmissible. Since the display you see on Flickr is generated from a digital file, the very same image can be displayed on countless different computers, and each one of these screen images is an authentic display of the work – not a reproduction. Granted, displays vary subtly because computer screens come in different sizes and are calibrated

differently. The same goes for photographic prints: two prints of an Edward Weston shot of Yosemite Valley may look a little different because they were handled differently in the dark room. Thus, a single photograph or a single digital image can have many displays which aren't perfectly identical in appearance. Yet only the digital image is transmissible.

What difference does transmissibility make to digital images? By permitting anyone to publish their work, sites like Flickr open up access to art. One interesting consequence of this accessibility is the exhibition and appreciation of images using aesthetic standards not accepted by the art world establishment. Henri Cartier-Bresson is arguably the paradigm of classic art photography, but a Cartier-Bresson photo recently posted on Flickr as a prank was dismissed by Flickr critics as "gray, blurry, small, odd crop"![4] Traditionalists guffaw, but the verdict is correct by the aesthetic standards of the Flickr community. Getting into a dispute about the correctness of these standards misses the point. The point is that, in the past, artists had to reach an audience through the physical confines of the galleries and so had to meet (or attempt to change) the aesthetic norms of gallery-owners and art collectors. Digital image-makers can reach niche audiences with diverse aesthetic expectations.

Speaking of diversity, let's not forget that not all art made for digital display is pictorial. A borderline case is Jenny Holzer's site-specific light projections. Figure 1.2 shows part of an installation where digital text scrolled down the facade of St Paul's Church in Covent Garden, London. In this work, Holzer appropriates an architectural setting (which certainly isn't digital), and she adds a digital component in the form of text. Needless to say, digital art displays can involve sound, too, and there's plenty of music that's made nowadays for digital recording and playback. But what about literature? Isn't it always an oral and print medium?

The displays of poems have been arrangements of words on paper for as long as poetry has been made to be read (and not just spoken and heard), but digital poetry arranges words on a screen. Unlike ink on paper, screens can be made to update in real time. Jim Andrews's 1997 "Seattle Drift" is made up of words that move, drifting apart when the reader clicks "do the text," freezing in place when she clicks "stop the text," then returning to their starting points when she clicks "discipline the text" (fig. 1.3).[5] In this poem, the display is an arrangement of words on screen through time, hence moving.

Motion enlivens verse in "Seattle Drift," text overlays architecture in Holzer's light projections, and ASCII art builds images out of text. The digital

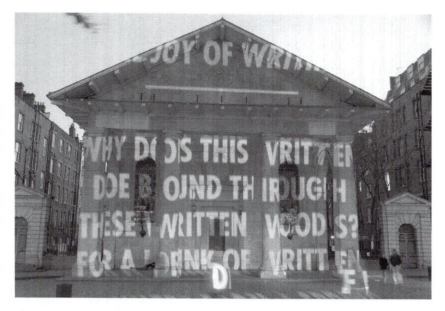

Figure 1.2 Jenny Holzer, *For London*, 2006

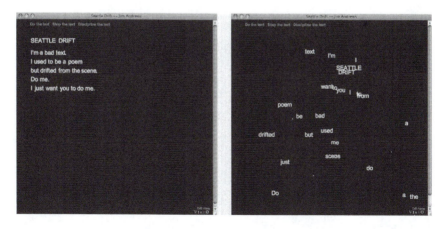

Figure 1.3 Screenshot of Jim Andrews, "Seattle Drift," 1997

display crosses traditional media boundaries with relative ease. Multimedia art is nothing new, of course. For centuries theater has merged storytelling in song with dance and scenographic images in a built space. Movies combine the arts of pictures, sound, and storytelling. What's new is that multimedia digital displays are generated on one machine, an all-purpose representation device that deals with information in a common, digital code. By encoding text, sound, and still and moving images, digital displays offer one-stop multimedia.

Digital techne

Digital art is either made by computer or made for display by computer in a common, digital code. The digital display is obvious enough when we come across it, and so is its impact, which includes new opportunities for multimedia and new avenues for audiences to access art. A less obvious "game changer" is the use of digital encoding to make art.

The realm of art made digitally is larger than the realm of art made for digital display. All art that's made for digital display is made digitally, but not all art that's made digitally is made for digital display. The Australian artist Stelarc performs pieces using his own body and robotic attachments. In *Exoskeleton*, he's embedded inside and manipulates a six-legged walking robot which he deploys on stage (fig. 1.4). Performances of *Exoskeleton* aren't digital – they're made up of the movements of the robot and the embedded artist. Even so, Stelarc's robotic appendages process digitally-encoded information. So *Exoskeleton* is an example of a work that uses computer-based digital encoding but doesn't have a digital display. There are other examples. The American artist Chris Finley takes digital images and painstakingly copies them in paint on canvas. The MIT engineer and composer, Tod Machover, wrote his *Toy Symphony* using his digital Music Toys for subsequent performance on acoustic instruments. Actors study their lines on Kindles, poets lay out verse in Word, and architects design buildings with software packages like Rhino and CAD.

Artists typically make works of art with tools, which range from the very simple, like pieces of chalk for drawing, to the very complex, like the diatonic scale used to compose most Western music. Some of these tools can be described as purely pragmatic and some as purely cognitive (and some as a mix of both). A chisel is a purely pragmatic tool because it's designed to change a piece of the physical world. A dictionary is a purely cognitive tool because it's designed to extend what the artist knows or can hold in

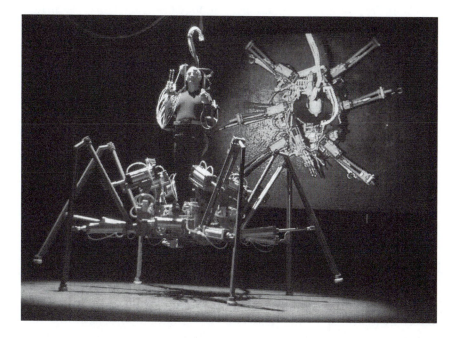

Figure 1.4 Still of Stelarc, *Exoskeleton*

memory. The standard painter's palette is a mixed pragmatic and cognitive tool. It's a pragmatic tool for holding bits of paint, and it's also a cognitive tool set up to allow the painter to arrange those bits of paint using a system based on the color wheel, thereby helping him to see how to mix any color he wants.

Computers stand out as cognitive art tools (or as mixed cognitive and pragmatic tools). Artists, who create art by using their brains to process information, can offload some cognitive work, letting computers process information for them. The tactic works because we can set up computers to take on some cognitive tasks.

Some of these tasks are ones anyone could do anyway, like spellchecking or typesetting. Other tasks would require highly specialized training. Google Sketchup is a remarkably easy to use three-dimensional design tool that gives practically anyone some basic drafting ability. Machover's Music Toys enable their players (especially children) to shape the melodic and rhythmic contours of music with simple and intuitively obvious gestures. In machinima (which comes from machine + anime), animated movies are made using the "engines" that generate the graphics in video games like

Doom and The Sims. A classic example is Strange Company's 1999 animation of Shelley's poem "Ozymandias."[6] Sims Facelift is a tool for creating and manipulating two-dimensional images of faces with quite a bit of "personality." Using it won't put you in a class with such masters of the character portrait as Franz Hals, but not every portraitist is a Hals.

The idea that anyone can be an artist because computers simplify or automate some artistic tasks can be turned around. If artistry requires creative skill, and making art with computers involves little or no creative skill, then doesn't it follow that computers don't expand opportunities for artistry? On the contrary, they direct us away from true opportunities for artistry that come with traditional art-making tools. This is a common complaint about the intrusion of computers into the domain of art, and the next chapter takes it up in earnest. For now, consider some instances where digital art has pushed the boundaries by equipping artists to make works with features never seen before.

Everybody knows how digital photographs are vulnerable to manipulation with applications like Photoshop.[7] The standard line is that "Photoshopping" threatens to topple "photographic truth" or revolutionize how we think about it, since it proves that photographs are no longer direct and reliable records of reality. However, photographs have been manipulated since they were invented, and while some touch ups were obvious (and were intended to be noticed), some are still difficult to detect. In practice, there's never been a sharp boundary between drawing with the pencil of nature and drawing with pencil in hand.

The digitally-manipulated photographs of the German photographer, Andreas Gursky, are compelling not so much because they play up the manipulation angle but rather because they play up the truth angle. In his 99 Cent (fig. 1.5), Gursky carefully and seamlessly pieces together what began as several images, but this manipulation brings us closer to reality, evoking a strong, even disorienting effect of realism (which is mostly lost in reproductions). At three by two meters, the image is huge, yet the closer you look, the more detail there is to see, and that detail acts as a gravitational field that pulls you ever deeper into the image. The image replicates what we do when we first survey a scene and then move up closer for a better look, getting more detail. Freeing its viewer from the static viewpoint of the lens, 99 Cent conveys something of the experience of mobile, curious, and, hence, more informative looking.

A share of the credit for the iconic architectural work of Frank Gehry goes to CATIA, a three-dimensional design application. The architectural

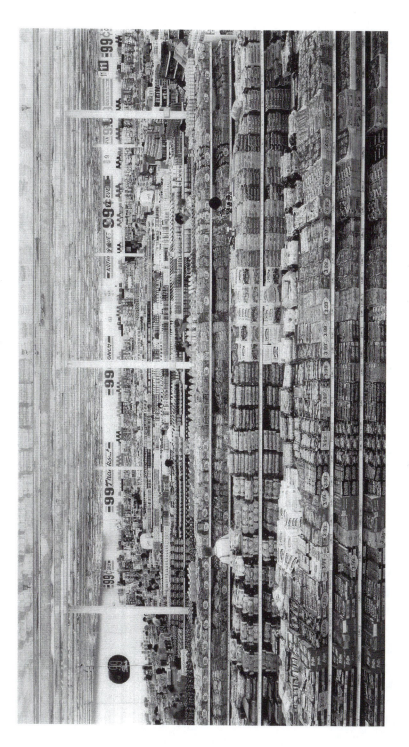

Figure 1.5 Andreas Gursky, 99 Cent, 1999

process typically decomposes into two main phases. In the first, the task is to create a set of instructions – "construction drawings" – which communicate the architect's scheme to the builder, who, in the second phase, uses them to erect the physical building. Until recently, construction drawings were paper drawings, and this imposed a limitation on what could be built: no scheme could be built unless it could be set out in a drawing that the builders could read. CAD automated this process without changing the basic set up – that is, without departing from the language of drawing. Yet it's easy to see that it would be practically impossible to create a set of drawings of a building like Gehry's Guggenheim Bilbao in Spain that could accurately guide its construction (fig. 1.6). Instead, Gehry used CATIA, a software application that had been written to design the Mirage fighter jet. CATIA freed Gehry to engineer curved surfaces that would not fall down and also to output instructions for fabricating and assembling each piece of the building. Gehry remarks that,

> This technology provides a way for me to get closer to the craft. In the past, there were many layers between my rough sketch and the final building, and the feeling of the design could get lost before it reached the craftsman. It feels like I've been speaking a foreign language, and now, all of a sudden, the craftsman understands me.[8]

Language is a tool in art-making, and CATIA provides such a language.

Digital art making even means that we can dispense with the human artist entirely. More than a decade ago, David Cope at Stanford University built EMI (Experiments in Musical Intelligence), which writes entirely new works of music in the styles of the great composers. For example, when given a number of Rachmaninoff piano sonatas to analyze, EMI creates entirely new sonatas in the style of Rachmaninoff.[9] I once saw Cope play two Rachmaninoff-style sonatas for an audience of music experts. One was by Rachmaninoff and the other by EMI, but the audience couldn't tell them apart. Likewise Harold Cohen's AARON makes entirely new drawings that are hard to distinguish from those of a skilled artist (fig. 1.7).[10] Some of them have been shown at venues including the Tate Gallery, SFMoMA, and the Stedelijk Museum in Amsterdam. When one of these was labeled as a "digital print by Harold Cohen," Cohen objected, and the label was changed to attribute the work to "AARON, a computer program written by Harold Cohen."[11] Alan Turing proposed that a machine possesses artificial

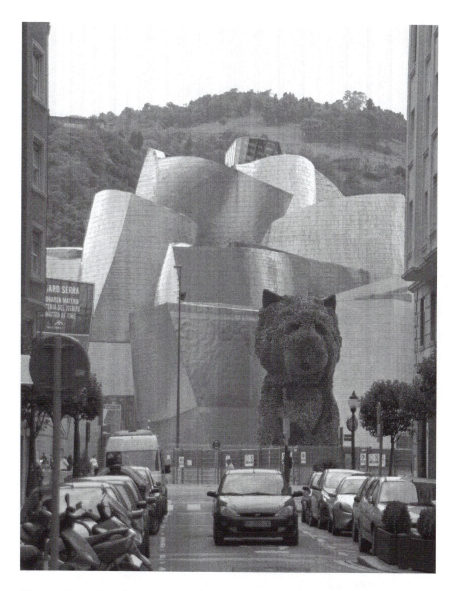

Figure 1.6 Frank Gehry, Guggenheim Museum, Bilbao, 1997

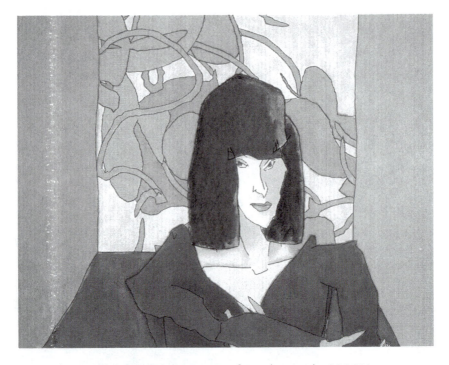

Figure 1.7 Harold Cohen, *Clarissa*, 1993, after a drawing by AARON, a computer program written by Harold Cohen

intelligence when its behavior can't be distinguished from human behavior.[12] By that test, EMI and AARON are examples of artificial artistry, for they do what humans do, by making art.

Digital art media

Works of art are first and foremost objects of appreciation, and they're normally made with appreciation in mind. Sadly, philosophers haven't yet worked out a thorough and well-tested theory of appreciation, but a partial understanding will do for now. As we've already seen, the fact that a work has a digital display or that it was made by means of a digital process sometimes makes a difference to appreciation – and sometimes it makes no difference whatsoever. The idea of digital art media captures this distinction.

The technology used in the display or making of a work of art may or may not be relevant to appreciation. Imagine this dialogue:

A: What do you think of this piece of cedar sculpture?
B: Not much. It looks rough. Crude, really.
A: You realize that it was made with a chainsaw?
B: That changes everything – what finesse!

By the end of their conversation, A and B appreciate the sculpture in a way that acknowledges how it was made. Moreover, B would have made an error in appreciation had she refused to change her mind. Contrast:

A: What do you think of this painting?
B: I love the freedom of gesture.
A: You realize that the artist measured the wood for the stretcher using a metric ruler?
B: Now that you mention it, it is stiff in expression.

Something's gone wrong in this conversation: it shouldn't make a difference to appreciation whether the artist measured the stretcher in centimeters, inches, or cubits.

Let's say that a technology is an artistic medium for a work just in case it's use in the display or making of the work is relevant to its appreciation. The chainsaw is a medium in the example above, but not the metric ruler. Extending the idea beyond single works, we can say that a technology used to display or make a group of works is a medium just in case the use of that technology is relevant to appreciating works of that kind. According to this theory, chainsaw sculptures are such a group, but not paintings-on-stretchers-measured-with-metric-rulers. Just as a theory of digital art isn't supposed to fit our much looser, everyday use of the words "digital art," this theory isn't meant to line up with what everyone has in mind when they talk of "media." It's meant to focus our attention on the role of some technologies in art appreciation by labeling those technologies as "media."

So digital art media are technologies that are used to make or display art works and that properly figure in appreciation. CATIA is a digital medium if it's appropriate to appreciate the Guggenheim Bilbao in light of the fact that Gehry used it to design the building. MP3 is a digital display technology, but it's not a digital display medium, because it's irrelevant to our appreciation of songs whether they're recorded in MP3 or ACC or vinyl. (Of course, you can appreciate the qualities of different *recordings*, but that's not the same as appreciating the *songs*.)

Old wine in new bottles?

The cases presented so far give a taste of the variety of digital art. The curator Christiane Paul remarks that "'digital art' has become an umbrella term for such a broad range of artistic works and practices that it does not describe one unified set of aesthetics."[13] Umbrella terms are normally used to cover a fragmented array of phenomena. Indeed, every one of the digital art works discussed in this chapter belongs to a traditional art form. ASCII images, Photoshopped images, and drawings made by artificial intelligence are still visual art. Drifting lines of verse are still poetry and robotically enhanced dance is dance nevertheless. Museums built with CATIA remain architecture, as piano sonatas composed by computers are music. In the words of the media theorist Lev Manovich, digital media are "graphics, moving images, sounds, shapes, spaces, and texts that have become computable."[14] Accepting this truth is the first step to seeing why digital art isn't a new art form.

No disrespect to digital art is intended. In my humble opinion, Gehry's Guggenheim Bilbao is a masterpiece, I confess that Gursky's 99 Cent held me for a good half-hour when I saw it in person, and I'd go out of my way to catch a performance of Exoskeleton. You and I might disagree on particular cases, but we're likely to agree that some digital art is very interesting. We might even agree that some digital pieces are among the very best art of the past two or three decades. Granting all of this, the status and importance of digital art doesn't rest on its being a new art form.

Some experts point out that to properly appreciate works of digital art, we must locate them squarely in relation to the traditional art forms and media. We should be aware of the process that Jay David Bolter and Richard Grusin called "remediation." According to Bolter and Grusin, digital art defines itself by borrowing from older art media. This borrowing takes a special form. It's not the kind of borrowing that occurs, for example, in movie versions of books. The movie version of the Da Vinci Code takes its story from Dan Brown's novel, but the medium of the novel isn't part of the movie. Remediation is borrowing where "one medium is itself incorporated or represented in another medium."[15] Digital photographs remediate film photographs, and digital music remediates traditional music. In other words, digital photographs belong to the same broad tradition as film photography, and likewise for the other digital art media, each of which belongs to a traditional art form. Suppose we ask: how many digital art media are there? The answer is at least as many as there are

art forms with digital works. So digital art isn't a single, new art form. Computers gives us "a new cinema, a new television, and a new kind of book. The computer does not fuse all its representations into a single form, but presents them in great variety."[16] In a slogan, digital art media afford new ways of making works in old art forms – they put old wine in new bottles.

These thoughts can be repackaged as an argument to show that digital art isn't a new art form. This argument taps into the idea that a medium impacts the proper appreciation of a group of works: it begins with the assumption that art forms are *appreciative art kinds*.

Art kinds are simply groups of art works that have a common feature that distinguishes them from other kinds of art. Any feature will do, so there are countless art kinds. Some examples: poems composed on a Tuesday, works containing no quarter rests, and paintings made by French artists whose last names are five letters long. Once you get the hang of it, it's easy to add to this list and discover new art kinds, but the game is obviously a little silly. Unlike painting, melodrama, and mannerism, which seem to be important categories in art appreciation, such categories as Tuesday poems and quarter restless music are concocted and pointless. They aren't the art kinds that come in handy when we go about appreciating works of art.

Appreciating a work normally requires us to place it in a comparison class of other works.[17] For example, viewed simply as an example of twentieth-century abstract painting, Piet Mondrian's *Broadway BoogieWoogie* comes across as spare, rigid, and controlled. However, it's joyous, full of movement, and exuberant when compared to other paintings by Mondrian.[18] How you see it depends on whether you view it against the backdrop of Paul Klee, Wassily Kandinsky, Hans Hoffman, Jackson Pollock, and Willem de Kooning, or whether you view it against the backdrop of Mondrian's usual and much more austere style. The art kinds we normally use as contrast classes in appreciation are *appreciative* art kinds:

a kind is an appreciative art kind just in case we normally appreciate a work in the kind by comparison with arbitrarily any other works in that kind.

Comics are an appreciative art kind because we normally appreciate Spiegelman's *Maus* in comparison to practically any other comic – Seth's *Clyde Fans*, George Herriman's *Krazy Kat*, or Hogarth's *Rake's Progress*. Tuesday poems and quarter restless music aren't appreciative art kinds because they don't normally figure as comparison classes in appreciation.

Putting the idea another way, an appreciative art kind is a group of works that share a distinctive feature in common and that are normally appreciated partly for having that feature. *Krazy Kat* belongs to the appreciative art kind of comics because we normally appreciate it partly for its telling a story through a sequence of still images. Songs aren't normally appreciated for doing without quarter rests, and that's why quarter restless music isn't an appreciative art kind.

If art forms are appreciative art kinds, then digital art isn't an art form. You don't appreciate a digital work by comparison with *arbitrarily any other digital work*. Of course, you normally do appreciate a digital image by comparison with other digital images, and you normally do appreciate a digital composition by comparison with other digital music. However, the comparison class for Gursky's *99 Cents* does not include a composition by EMI, and the comparison class for Gehry's museum in Bilbao does not include machinima movies. Digital art is an art kind, but it's not an appreciative art kind, and art forms are appreciative art kinds. So digital art isn't an art form. Computer-based digital encoding is a medium for making works in many different art forms.

Printing technology makes a good analogy. Presses are used to print books and also etchings and lithographs. Moreover, the printing press is an artistic medium, since it's relevant to appreciating a Gutenberg Bible that was printed using a letter press, as it's relevant to appreciating a Rembrandt etching that was made using print technology. Even so, the class of art works made using printed presses isn't an art form – it's a group of works in different art forms. We normally appreciate the Gutenberg Bible as a printed book and the Rembrandt etching as a printed image.

Does that mean that a work's digital origins shouldn't have any impact on our appreciation of it? No! Of course it's appropriate to appreciate *Exoskeleton* as digital dance and to appreciate AARON's work as digital drawing. They may even be outstanding examples of dance or drawing. Although the generic category of digital art isn't an appreciative art kind, the more specific categories of digital movies, digital photography, and digital music are appreciative art kinds. These aren't art forms: they're subcategories within the art forms of movies, images, and music.

Only some new art technologies give rise to new art forms. On one hand, the acrylic paints marketed in the 1950s allowed artists like Morris Louis and Mark Rothko to achieve entirely new effects. Likewise, the invention

of the elevator and steel frame construction with curtain walls ushered in the development of the modern skyscraper. Acrylic paint and steel frame construction were new media but didn't generate new art forms. On the other hand, the invention of film and the movie camera and projector gave us cinema – a new art form. The lesson is that some but not all changes in art technology beget new arts. The challenge for the rest of this book is to demonstrate that the invention of computer technology gave us a new art form. Not digital art but computer art.

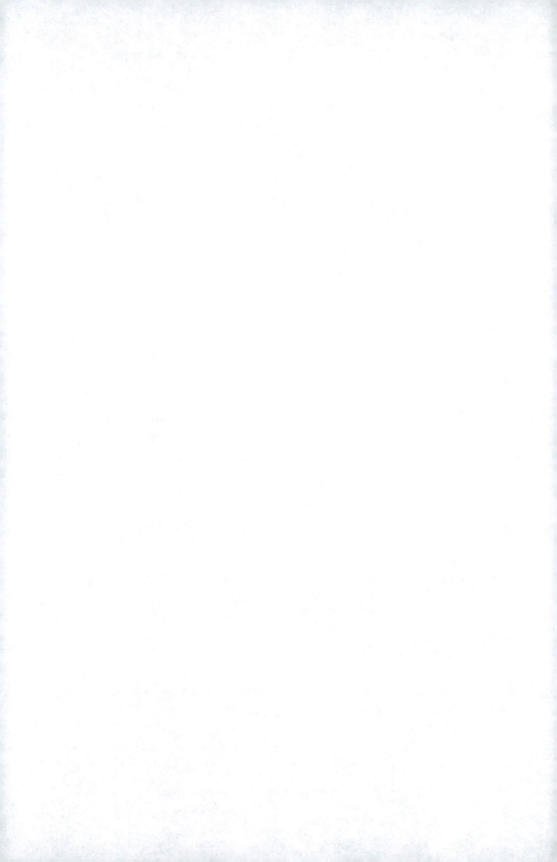

2

A COMPUTER ART FORM

The artist must not forget that each of his materials conceals within itself the way in which it should be used, and it is this application that the artist must discover.

Wassily Kandinsky

The previous chapter defined digital art and then presented an argument that explains why digital art isn't a new art form. This argument also tells us what's needed to show that computer art is a new art form. The task is to explain why computer art is an appreciative art kind. In approaching this task, it makes sense to address three questions: the specialization question, the value question, and the art question.

What is computer art?

Art kinds are groups of works that share some common feature not seen in other kinds of art. So if computer art is an art kind, then works of computer art must share specific features that set them apart from works in other art forms. What features? That's the *specialization question*:

> what features of some computer-based works make them works in the computer art form and set them apart from other kinds of art?

Chapters 3, 4, and 5 take up the specialization question in detail. For now, here are five real-life examples that suggest a working theory of computer art.

Jeffrey Shaw, Golden Calf, 1995 (fig. 2.1)

Before you stands a white plinth like those used for displaying statues in museums. Next to the plinth is a portable LCD display. When you pick it up, it shows the space in front of you; and when you turn to the plinth, it shows you the plinth surmounted by a golden calf. You can inspect the calf from every angle as you circle the plinth with the display. Perhaps you recall Poussin's Adoration of the Golden Calf or the original Old Testament story where the golden calf is a figure of idolatry – taking an image for something it's not.

Ken Goldberg, Telegarden, 1995–2004 (fig. 2.2)

A room in Austria contains a small garden over which hovers a robot equipped with a video sensor and appendages for delivering water and seeds. Along with thousands of other telegardeners around the world, you regularly visit a website that allows you to move the robot to get a view of different sectors of the garden and tend the plants in those sectors. According to one commentator, the work "creates a physical garden as an environment to stage social interaction and community in virtual space. Telegarden is a metaphor for the care and feeding of the delicate social ecology of the net."[1]

Damian Lopes, Project X, 1997 (fig. 2.3)

You're looking at a screen of verse telling part of the story of Vasco da Gama's voyage round Africa to Asia. Every word of the text is a hyperlink that transports you to a new screen that elaborates, opposes, or recontextualizes the previous screen. The text on this screen is also hyperlinked. Having selected several links you come to realize that the sequence of screens comprises an epic with no prescribed order of reading. Reading the epic is an act of navigation into the unknown, and you must assemble what you learn from each trip through the site into a map that tells the whole story.

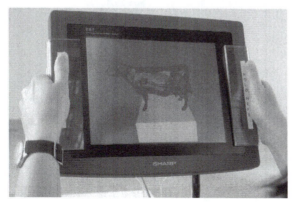

Figure 2.1
Stills of Jeffrey Shaw,
Golden Calf, 1995

Figure 2.2 Still of Ken Goldberg, *Telegarden*, 1995–2004

13 January 1499

unable to navigate
with the hands that remain

we anchor
at the Baixos de São Raphael

set fire to the ship
of that name

Figure 2.3 Screenshot of Damian Lopes, *Project X*, 1997

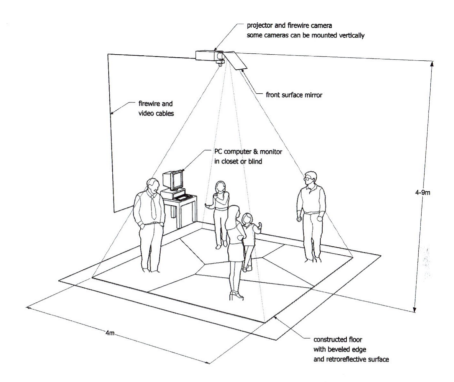

Figure 2.4 Schematic of Scott Snibbe, *Boundary Functions*, 1998

Scott Snibbe, Boundary Functions, *1998 (fig. 2.4)*

You and a companion step onto a slightly raised platform and a line is projected onto the floor halfway between you. As more people join in, more lines are drawn, creating an irregular tiled pattern. Try as you might – and some children who have just stepped in are trying very hard – you cannot step outside your boundary. Someone remarks that Boundary Functions was the title of the doctoral thesis of Theodore Kaczynski, the Unabomber.

Hisako Yamakawa, Kodama – Mischievous Echoes, *2005*

As you approach the room you hear voices, but when you enter you find yourself in a quiet space bounded by rich moving images of an uninhab-ited forest. The voices return when you leave the room and, if you spoke when you were in the room, you find that one of the voices mischievously

imitates you. The guide explains that, in Japanese lore, *kodama* are tree spirits that steal and play with people's voices. You return to the room to have a word with them.

These five works have very different kinds of displays. The display of *Golden Calf* is a plinth and a digital image on an LCD screen. *Telegarden*'s display is a living garden and digital images of that garden as well as the movements of the robotic armature. *Project X* displays images alongside text arranged into lines of verse for viewing in a web browser. *Boundary Functions* projects Voronoi tessellation patterns in laser light onto a space. *Kodama* involves sound as well as images. Notice that not all of these displays are digital – there's nothing digital about *Golden Calf*'s plinth, for example.

Yet all five displays are associated with traditional art forms. All five use images. *Golden Calf* borrows from sculpture and *Kodama* incorporates elements of cinema and music. *Project X* involves poetry, and there's obviously some theater in *Boundary Functions* and, less obviously, in *Telegarden* too. Finally, *Telegarden* takes traditional landscape architecture in a new direction. Every work of computer art must present a display of some kind, and the display will exploit text, static images, moving images, three-dimensional objects and spaces, bodily movements, or sounds. These are the building blocks of literature, pictorial art, film, sculpture and architecture, theater, and music. It's easy to doubt that there's a distinctive computer art form. Why not say that our five examples are simply digital art? All of them are made by computer and some have displays in a common, digital code.

Something sets *Golden Calf*, *Telegarden*, *Project X*, *Boundary Functions*, and *Kodama* apart from traditional art. All five are interactive. In every case, what happens with the work is a result of some activity on the part of the audience. Moreover, this interaction is negotiated by a computer. A computer generates the display of *Golden Calf* from input sensors in the LCD screen. *Telegarden*'s robot takes instructions submitted via a website, and *Project X* also takes input from a website in order to determine what text and images to display. Like *Golden Calf*, *Boundary Functions* uses a location sensor to project images, but it runs a Voronoi diagram algorithm to direct lasers. *Kodama* records and manipulates sound for playback.

Interactivity can be defined in a dozen different ways. On some definitions, every work of art is interactive, or many are, so that interactivity isn't specific to computer art. The next chapter seizes this problem by the horns. For now, it's enough if you grant that the five examples are clearly interactive in a way that you recognize, even if it remains to be defined.

It will be enough to compile a working theory of computer art that will tell us which works belong in the art form.

> CAF: an item is a computer art work just in case (1) it's art, (2) it's run on a computer, (3) it's interactive, and (4) it's interactive because it's run on a computer.

Let's unpack this a little.

What is it for a work to be run on a computer? The next chapter supplies the answer, but CAF tells us this much. Computer art works exploit the technology of computing in order to achieve interactivity. Thus not all works that are in some sense run on a computer are works of computer art. My iPod plays my favorite tunes for me, and in some sense they're run on a computer, but playing Radiohead on an iPod isn't interactive in the same way as our five cases. The lesson is that we should expect to get a sharper idea of interactivity and of the role of computers in computer art at one and the same time – that's the job of chapter 3.

Second, CAF allows that the displays of computer art works overlap with traditional art forms – images and text, for example. In other words, CAF is consistent with the obvious fact that computer art shares a lot with digital works in traditional art forms. However, it doesn't follow that computer art is the same as digital art. When images, text, sound, and traditional art media appear in computer art, they're harnessed to achieve something not found in other art: interactivity.

So CAF begins to frame an answer to the specialization question: computer-based interactivity is the special feature that distinguishes computer art from digital art and indeed all the other arts. But it's only the *beginning* of an answer. The five works described above are interactive in some interesting sense, but we must pin down exactly how they're interactive. It had better turn out that they're interactive in a special way, and it had better turn out that their interactivity exploits computing technology, otherwise we should talk of "interactive art" instead of "computer art."

But is it art?

The first clause of CAF boldly assumes that some interactive, computer-based works are works of art, and this raises the treacherous question: what is art? After all, a critic of CAF might say, "I concede that some computer-based works are interactive in some special sense. Define it however you like.

Nevertheless, you can't get art through interactivity. These interactive works you describe are all very interesting, but they're not art." In other words, nothing satisfies both clause (1) and also clauses (2) to (4) of CAF. Whereas this critic assumes a view of art that rules out computer-based interactive works, CAF implies a view of art that makes room for computer-based interactive art. Whose view of art is right? What's the answer to the *art question*:

why do computer-based interactive works count as art?

Chapter 7 tackles this question and a related puzzle. Don't video games fit clauses (2) to (4) of CAF? Aren't they interactive because they're run on computer? If so, then shouldn't we count video games as art?

And is it valuable?

Chapters 3 to 5 argue that computer art, as defined by CAF, is an appreciative kind, and chapter 7 argues that it's an art kind. So computer art is an appreciative art kind. We normally appreciate works like *Project X*, *Telegarden*, *Golden Calf*, *Boundary Functions*, and *Kodama* by comparison with each other, for their computer-based interactivity. Presumably, though, we appreciate art works in order to get at their value. There's no point in appreciating works of computer art if they're utterly worthless. Hence the *value question*:

what is the value of computer art works?

With the help of CAF, we can be more specific: what's the value of an item that's run on a computer, that's interactive, and that's interactive because it's run on a computer?

The value question doesn't come up in a vacuum. Computers are the objects of some suspicion, and there have been well-publicized critiques of computer-based art. Since those who have suspicions about computers don't clearly differentiate digital art from computer art, let's use "computer-based art" neutrally, to apply to either digital art or computer art. In chapter 6, we'll try to figure out which critiques specifically target digital art and which ones target computer art as defined by CAF. An answer to the value question will depend on CAF as an answer to the specialization question.

The argument from the creativity sink. Some complain that computer technology limits the artist's control over her work. If the value of art lies in its providing

an outlet to individual expression, then works made by computer lack this value. Putting the argument explicitly,

1 a work has value as art only to the extent that it expresses the creativity of its maker,

2 computer-based art works inhibit their makers' creativity,

3 so computer-based art works lack artistic value.

If both premises of this argument are true, then its conclusion is true; but are its premises true? Premise (1) is rarely stated explicitly, and it's dubious. Accept it for now. Premise (2) is more interesting because the reasons given for it bring out a conception of computer-based art.

Some complain, in support of (2), that computers *standardize* the art-making process.[2] Although the computer is in principle a powerful and flexible machine, artists are severely constrained by software packages which impose a uniform appearance on works – like the notorious "Photoshop look." Software standardizes, and an artist who adopts some software adopts its standards. The argument is that a work doesn't express the creativity of its maker if it's made using a medium that standardizes the art-making process, and computer media standardize the art-making process, so computer-based works don't express the creativity of their makers.

A second reason for (2) is just as compelling. In his book on virtual reality art, Oliver Grau argues that the makers of interactive virtual reality art must cede control of their works.[3] In some measure, audience members gain what the artist gives up because they get to interact with the work. However, little of the control that the artist gives up goes to the audience. Virtual reality works are effective only in so far as they mimic reality, so the virtual reality artist is compelled to copy reality and has no room to comment on it critically: critical commentary would spoil the effect. As Grau puts it, "the technological paradigm of virtual reality [does not] acknowledge the responsibility of the artist to channel the suggestive power of the images and environments."[4] The argument is that a work can't express the creativity of its maker if its maker is bound to copy reality without critical comment, and makers of virtual reality art are bound to copy reality without critical comment, so virtual reality works don't express the creativity of their makers. Note that this argument makes virtual reality the defining feature of computer-based art.

The argument from the vanishing work. Clement Greenberg, one of the most influential art critics of the last century, thought that the best art of our time

is characteristically about its own medium. He found its excitement "to lie most of all in its pure preoccupation with the invention and arrangement of spaces, surfaces, shapes, colors, etc. to the exclusion of what is not necessarily implicated in these factors."[5] This doctrine about visual art easily generalizes to the other arts. Modern art aims to invite perceptual experience of medium and it's valuable when it succeeds in this aim. However, computer art hides its medium, so it fails as art. Laying out the reasoning:

1 a work (of our era) has value as art only to the extent that it invites experience of medium,

2 computer-based art works don't invite experience of medium,

3 so computer-based art works lack artistic value.

Again, if (1) and (2) are true then (3) follows. The Greenbergian doctrine summed up in (1) is at best a point of hot debate, so let's be generous and accept it for now. By focussing on the case for premise (2), we might learn something about the nature and value of computer art.

The case for (2) is this.[6] Media are perceptually available in traditional art, but not in computer-based art. A painting, for example, is made by applying paint to a surface, and Jackson Pollock makes paintings in which we can see the act of painting. Likewise, color is a building block of painting, and Joseph Albers's paintings thematize color and color effects. In these works, the technology of painting is made visible to the viewer. However, nothing like this happens with computer-based art. A computer might show you a pixelated image or play you a sequence of sounds, but it doesn't reveal to you the computer technology underlying the image or sounds. The code that underlies the audio-visual display is invisible. Put metaphorically, "the computer is the ultimate black box where production ... is occluded."[7]

This argument seems to fit digital art and perhaps other new media arts (like movies and television), but not the traditional arts. It's an open question whether it applies to computer art.

The argument from mind numbing. This critique of computer-based art should sound familiar. The value of an art work is measured by its power to provoke and sustain hard thinking, and works that fail this test of profundity fail as art. Such is the destiny of computer-based art, which gives us techno-dazzle in place of content, blocks serious reflection, and corrodes the imagination, all the while blinding us to its mind-numbing effects. Deleting the strong language from this bill of indictment, we get:

1 a work has value as art only to the extent that it abets active thought,

2 computer-based art works impede active thought,

3 so computer-based art works lack artistic value.

This reasoning borrows from the ideas of writers like Greenberg, Max Horkheimer, and Theodor Adorno, who denounced mass art – especially movies, television, and popular music – as mind numbing.[8]

Premise (1) is credible enough as long as "active thought" is given a reasonable interpretation, and the reasons for (2) must connect a conception of computer-based art to a reasonable interpretation of "active thought." After all, nobody denies that all art requires *some* active thought. Horkheimer and Adorno concede that "quickness, powers of observation, and experience are undeniably needed to apprehend" mass art works, which nevertheless go about "stunting the mass-media consumer's powers of imagination and spontaneity."[9] Presumably, then, some other ingredient of "active thought" is missing from our encounters with computer-based art.

Two reasons for (2) come directly from other arguments. First, in support of the argument from the creativity sink, some accuse virtual reality works of stifling creativity by blindly copying reality. This is also reason to suspect them of impeding active thought. A convincing illusion of reality must be internally coherent. Thus it cannot tolerate contradictions and unlikely comparisons. But active thought grapples with contradictions and unlikely comparisons. So virtual reality works impede active thought. Second, in support of the argument from the vanishing work, some say that we can't attend to digital technology as a medium. But active thought about art is thought about the medium of a work and how that medium affords experience and carries meaning.[10]

A third argument for (2) is entirely new. Virtual reality art and interactive art impede active thought because they're immersive, but active thought requires distance, which is incompatible with immersion.

Just as different situations afford or inhibit action, different situations afford or inhibit cognition. Being in the dark inhibits sight, being drunk inhibits memory, being in a library affords learning, and playing chess affords strategic planning. "Distance" is a condition of situations which afford active thought. The condition is never properly defined, but it's often described as affording selective and focussed yet leisurely attention. When there's distance, a thinker can inspect an object as she wishes, at the pace she wishes. Understood in this way, distance is essential to cognitive autonomy

– to thinking for yourself – and that makes it an essential precondition for critical evaluation. The art historian Aby Warburg called distance the "original act of human civilization."[11]

The argument is that computer-based art does away with distance. To begin with, virtual reality installations control spectators' attention, and any interactions are scripted and circumscribed. For Grau "a core element of art comes under threat: the observer's act of distancing that is a prerequisite for any critical reflection. Aesthetic distance always comprises the possibility of attaining an overall view, of understanding organization, structure, and function, and achieving a critical appraisal."[12] In addition, distance has a temporal dimension: distance means time to think. However, computer-based art is too fast for distance. Warburg originally made this complaint about the telephone and telegraph. Nowadays, Paul Virilio sounds the alarm about the cognitive tyranny of real-time processing.[13] Computer-based art manages the reactions of its audience so that they're no longer thinking for themselves.

The argument from mind control. Having enfeebled the mind, it's a short step to taking control. Horkheimer and Adorno argue that mass media, especially movies and television, feed their audiences with a formulaic diet that "produces, controls, and disciplines consumers' needs" by creating the illusion that "the outside world is the straightforward continuation of that presented in the screen."[14] Jean Baudrillard pushes the view that mass communication technologies only offer "the spectacle of thought and ... people opt for the spectacle of thought rather than thought itself."[15] Lev Manovich has added a new element to this argument.

According to Manovich, some mental processes are externalized.[16] Moving pictures externalize vision, for example, and stories externalize narrative reasoning. We think with these externalizations – and that's their power. We would be lost without maps, which externalize way-finding, for example. The trouble is that externalizations can be regulated and manipulated, and in so far as our own thoughts depend on externalizations, they're also regulated and manipulated. Manovich fears exactly this:

> Mental processes of reflection, problem solving, memory and association are externalized, equated with following a link, moving to a new image, choosing a new scene or a text ... Now, with interactive media, instead of looking at a painting and mentally following our own private associations to other images, memories, ideas, we are asked to click on the image on the screen in order to go to another image on the screen, and so on. Thus we are asked to follow pre-programmed, objectively

existing associations ... we are asked to mistake the structure of some-
body else's mind for our own.[17]

The result is that "interactive computer installations indeed represent an
advanced form of audience manipulation."[18]

Come to think of it, this worry isn't all that new – it goes back to Plato's
allegory of the cave, which echoes all the way down the centuries to *The
Matrix*. Plato's cave-dwellers, exposed only to images on the cave wall, are
under the illusion that what they see is reality. As a result, they're vulner-
able to manipulation if the shadows are cast by puppeteers. In the cinematic
update of Plato's cave, Neo's personal autonomy is linked to seeing the
Matrix for what it is – lines of green code – and hence to weaning himself
off it as a vehicle for his own thoughts.

Defining "free thought" as thought that's free of manipulation by exter-
nalization, here's the argument from mind control:

1 a work has value as art only to the extent that it abets free thought,

2 computer-based art works impede free thought,

3 so computer-based art works lack artistic value.

Grant (1) as usual. The strength of the argument rests on (2) and thus on
the idea that computer-based art externalizes thinking in a way that leaves it
vulnerable to manipulation.

The arguments from mind numbing and mind control are nakedly polit-
ical. Adorno writes that high tech art media are designed to "enhance the
power of the powerful" by blocking the "development of autonomous,
independent individuals who judge and decide consciously for themselves
... obstructing the emancipation for which human beings are as ripe as the
productive forces of the epoch permit."[19] As a Marxist, Adorno views art's
value as political and emancipatory: he assumes that a work has value as art
only to the extent that it abets active and free thought. By granting these
premises, we can avoid getting into a political debate and we can treat the
arguments from mind numbing and mind control apolitically.

All four critiques of computer-based art should be taken seriously by
anyone who is otherwise suspicious of the kind of speculation that toler-
ates ungrounded empirical claims and fanciful reasoning. Three of the four
critiques echo popular worries about new media. These media don't tap
the full extent of human creativity. New media art works don't challenge

the mind the way traditional works do. Given their seductive slickness and commercial ties, they manipulate us as consumers. These popular worries aren't expressed in precisely the same form as the arguments from the creativity sink, mind numbing, and mind control. Still, by addressing these arguments, we indirectly address popular worries and answer the value question. That's the task of chapters 6 and 7.

The specialization question, the art question, and the value question come as a package. Critics of the value of computer-based art begin with assumptions about its character – that it aims at virtual reality, for example. In other words, they begin with an answer to the specialization question. Beginning with a different answer may lead to a more optimistic response to the value question. So let's look at CAF as an answer to the specialization question.

3

LIVE WIRES

COMPUTING INTERACTION

It was not the machine but what one did with the machine that was its meaning or message.

Marshall McLuhan

"Interactivity" is a buzzword. Like other buzzwords, its meaning seems obvious though it's actually hard to define, and this makes it choice material for technobabble. We hear that bank machines and websites are interactive, that multimedia equals interactivity, that Microsoft Windows offers interactive help, that interactive TV is around the corner, and that interactive courseware supports interactive learning. One writer lists watching, finding, doing, using, constructing, and creating as modes of interaction; then another adds that "a light switch is interactive."[1] Honest commentators agree that interactivity is over-blown. But although interactivity would seem to make precarious footing for a theory of computer art, it's obviously the key to CAF:

> an item is a computer art work just in case (1) it's art, (2) it's run on a computer, (3) it's interactive, and (4) it's interactive because it's run on a computer.

This, too, is technobabble unless we take the buzz out of "interactivity." The operation should also unpack (4) by linking interactivity and computers to

reveal how computers play a role in computer art that's different from the role they play in digital art.

Interactivity

The trouble with "interactivity" isn't that it's meaningless. The real trouble is that it means too much – it means so many different things in so many different situations that it's hard to come up with a one-size-fits-all definition. Luckily, nothing as grand as a one-size-fits-all definition is needed. All we need is a theory of interactivity that's specifically tailored to computer art.

A good starting point is the five works described in the previous chapter. *Golden Calf*, *Telegarden*, *Project X*, *Boundary Functions*, and *Kodama* get their users involved in a way that traditional art works don't. All art engages us in one way or another, but these five works involve their users in a distinctive manner – interactively, you might say. The question is: how, specifically, are these works interactive?

To answer this question, there's no need to assume that interactivity in computer art is exactly the same as interactivity found elsewhere. Tennis is obviously an interactive activity, but in a different way from *Telegarden*. Conversation is interactive in the sense that you talk and your partner listens, then you switch, so that she talks and you listen. But although some say computer art works listen and respond, *Kodama* isn't interactive in that way. Neither is it much like social interaction, though works like *Boundary Functions* involve social interaction among many users.[2] Nowadays, computer interaction is defined in ways that mostly center on the notion of user choice, but interactivity in computer art may not match computer interaction in general. Trying to tie all these interactivities into a neat package is a recipe for frustration. Luckily, a theory of interactivity isn't obliged to cover interactivity in every domain, though it should fit all works of computer art.

You step forward and *Boundary Functions* redraws the space around you. You speak and *Kodama* mocks your voice. You tend a seed and *Telegarden* thrives. In each case, you do something which impacts the work's display. Had you acted differently, the display would go differently. No ordinary art is so responsive to what you do – only interactive art. Putting the idea in a formula:

> a work of art is interactive just in case it prescribes that the actions of its users help generate its display.

By this definition, some works are interactive and some aren't, but interactivity can also be measured:

> a work of art is interactive to the degree that the actions of its users help generate its display (in prescribed ways).

These two statements say what it is for a work of art to be interactive, but they're easily extended to define user interaction:

> a user interacts with a work of art just in case he or she acts so as to generate its display in a prescribed manner.

The virtue of these theories isn't that they draw sharp boundaries to close down discussion. Instead, they lay the foundations needed to understand interactivity. Consider each of their elements.

The idea that works of art have displays is familiar from chapter 1. A work's display is a pattern or structure that results from the artist's creativity and that we attend to as we appreciate it. It's words and images in *Project X*, images and sounds in *Kodama*, and a tessellation pattern in *Boundary Functions*.

Sometimes a work demands attention to features of its physical or social context as well as its display. You might get a painting wrong if you believe that it was made by Vermeer in the seventeenth century and not in the twentieth century by Van Meegeren (who faked more than a dozen Vermeers). Your knowledge of nineteenth-century ideas about the social role of women might enrich your experience of the sights and sounds of an opera. All this is fine. Emphasizing that a work is appreciated by apprehending its display doesn't push aside context, which can also factor into appreciation.

According to the above theory of interactivity, an interactive work has a display that changes depending on the actions of its users. So its display is variable. This variability can take two different forms.

Some works of art are repeatable. A song like "My Way" is repeated in many performances – by Frank Sinatra, Sid Vicious, and countless others. As different as these performances might be, they're still performances of the same song, and we hear the song when we hear any of its performances. Most works of computer art are repeatable in the same way. Many people can access *Project X* at the same time, and the same person can revisit it time and again. Each visit repeats the work, whose display varies from one visit to the next. For works like *Project X*, display variation comes through repetition.

Other works of art aren't repeatable. Gehry's Guggenheim Bilbao (fig. 1.6) is a physical object that occupies a single track through space and time (it never occurs in two places at once). Although it can be copied, the copies are mere copies and aren't instances of the same building. Likewise, some works of computer art are non-repeatable. *Telegarden* was the site of a single event, the tending of a garden, which unfolded at the hands of *Telegarden*'s users acting in concert. For works like this, display variation doesn't come through repeating multiple versions. It comes instead through variation in the succession of states that make up the one event.

Either way, the display varies as a result of user action. Michael Hammel writes, "if you do not touch an interactive work, you will have no experience of it, but if you do, you might get more than you bargained for."[3]

Of course, nothing stops people from traversing the "Do Not Touch" barrier surrounding traditional art works (fig. 3.1). If you slash a painting, you change its display, and you change the display of a movie when you view its scenes in scrambled order. So aren't just about all works interactive, if just

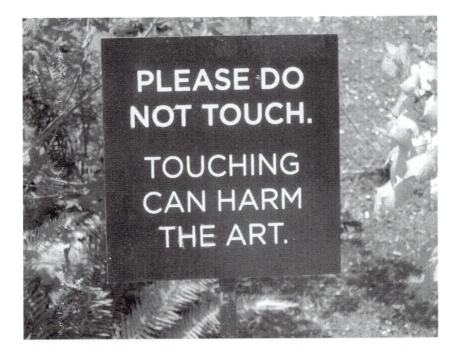

Figure 3.1 Do Not Touch sign

about every work's display can be changed in some way? And if *Mona Lisa* and *Chinatown* are interactive, then how useful is the idea of interactivity?

A good theory of interaction in art speaks of *prescribed* user actions. The surface of a painting is altered if it's knifed, but paintings don't prescribe that they be vandalized. Vandalism isn't interaction, and it's not an appropriate tactic for appreciating a painting. Likewise, *Chinatown* doesn't prescribe that we view its scenes by hitting "shuffle" on the DVD player, and watching a scrambled display of *Chinatown* is not an appropriate way to appreciate the movie. By contrast, *Boundary Functions* does prescribe that you walk all over it, and you correctly appreciate it by walking all over it. So interactive works prescribe that we act to impact the display, and we appreciate them by acting as prescribed.

Beyond the spectator

CAF implies that computer art users aren't mere spectators. *Mona Lisa*, "My Way," and *Chinatown* have spectators – listeners and viewers to be specific. Since computer art works are also seen and heard, they have spectators too. But unlike other art works, computer art works also have users, who go beyond seeing and listening, assuming that not all seeing and listening is interaction. At this point you might disagree. Surely engaging seriously with any work requires much more than seeing or listening. All art is interactive and the idea of interactivity is empty. Let's turn to this objection.

Marcel Duchamp famously remarked that "the spectator makes the picture."[4] Without doubt, appreciating much art is a strenuous activity. You must look, listen, and read, of course. You must also try out alternative interpretations of what you perceive; import relevant knowledge about authorship, genre, and history; and imbue the whole process with personal associations, if they're relevant. In sculpture, architecture, and landscape architecture, the activity includes a fair amount of physical movement too.[5]

Inspired by this point, some have reasoned that all art, not just computer art, is interactive. Here's Manovich, for instance:

> All classical, and even moreso modern, art is "interactive" in a number of ways. Ellipses in literary narration, missing details of objects in visual art, and other experimental "shortcuts" require the user to fill in missing information. Theater and painting also rely on techniques of staging and composition to orchestrate the viewer's attention over time, requiring

her to focus on different parts of the display. With sculpture and archi-
tecture, the viewer has to move her whole body to experience the spatial
structure.[6]

It appears that interactivity is a feature of all art, or a lot of art. However, this
appearance is misleading. Here's why.

Consider Holbein's painting, *The Ambassadors* (fig. 3.2). A glance reveals
two standing figures and assorted objects, but also a large smear of paint
across the bottom of the painting. If you position yourself correctly, right up
against the wall below and to the right of the painting, the smear pops into
shape as a skull. So a glance isn't enough – some movement is also required.
Nor does that suffice. What's the skull doing there? How does it relate to

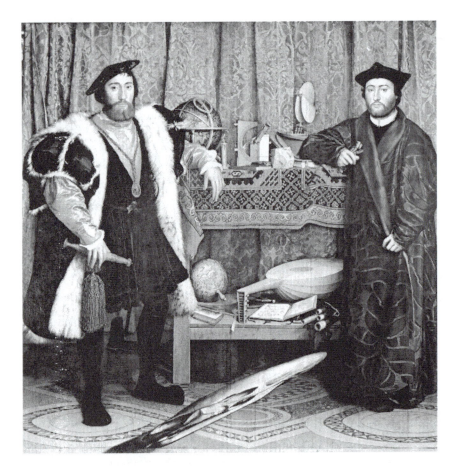

Figure 3.2 Hans Holbein, *The Ambassadors*, 1533

the figures and their accouterments? What's the picture about? What does it have to say? Answering these questions means rolling up the sleeves and getting to work. The *Ambassadors* demands active appreciation.

Active appreciation certainly shapes your experience of The *Ambassadors*. It figures in what you attend to and hence what you notice, what you think, how you feel, and what value you ultimately credit to the work. Nevertheless, it doesn't generate the work's display – the pattern of shapes and colors on its surface. According to the definition of interactivity, users' actions don't merely shape their *experiences* of works – they help generate the works' *displays*. By contrast, spectators of The *Ambassadors* play an active role in their experiences of it, without affecting its physical surface. So users of interactive works do something more than what's done by traditional art spectators.

Where does this leave Duchamp's radical idea? Maybe Duchamp is right and an experience of a work makes it what it is. If you and I experience The *Ambassadors* differently, then we *ipso facto* experience different works. There are countless *Ambassadors* – one for each experience of it. Maybe, less radically, the work is one thing and the experience of it is another: the experience is external to the work. So you and I have different experiences of the same work: one *Ambassadors*, that's experienced many times over.

work = display + experience

work = display

experience experience

As a matter of fact, we needn't choose between these radical and moderate alternatives, for neither implies that your experience of a work helps generate its display. The radical is welcome to say that a work is its display *plus* the spectator's experience, so that different experiences make for different works. (Add context to the equation if you like.) On this model, there are many, many *Ambassadors*, which all have the same display. According to the moderate, a work is its display (add context if you like). Since the display is what we experience, one work is the object of many experiences. There's only one *Ambassadors*, which has been experienced many times. Either way, the display of a work is what it is, no matter how we experience it. So Duchamp's idea that experience makes the work doesn't imply that experience makes the display.

Active appreciation does not imply interaction. It doesn't help generate a work's display – its visual or sonic properties, its textual make-up, or

how it unfolds in time. The pattern of paint that makes up the display of *The Ambassadors* has hardly changed in centuries, but the patterns of words and images that make up the displays of *Project X* change with every reading. Whereas art of all kinds invites active appreciation, only some art is interactive.

The Ambassadors's appearance is static and yet I experience it differently from you, you experience it differently now than you did in the past, and we experience it differently from a seventeenth-century Englishman. The reason isn't that the work's display changes, but rather that we actively appreciate it in different ways. Some traditional works have changing displays – Alexander Calder's mobiles turn in the wind. Two factors explain why you and I might appreciate one of these mobiles differently: it has moved or we have appreciated it differently (or both). Interactive works are quite different from mobiles. They go the way they do because of what we do in the process of appreciating them.

Spinoffs

The special feature of computer art is its interactivity, which sets it apart from other art. The point isn't entirely new.[7] But some traits that have been used to define interactivity are better seen as its spinoffs. Thus some describe computer art works as choreographing the user's experience and as pulling off effects not foreseen by the artist.[8] Some say that computer art works are uniquely about their users.[9] Some propose that interactivity entails collaboration on the part of multiple users. These traits are often prominent in computer art works, but they're not essential ingredients of interactivity. Computer art works can grant their users considerable freedom or they can be entirely predictable to their makers. They can promote or inhibit collaboration on the part of multiple users. They can say interesting things about us as users or they can deflect attention entirely away from ourselves. Although the traits don't define interactivity, we'll see in subsequent chapters that computer art works often have these traits precisely because they're interactive.

Computing interactivity

According to CAF, computer art works are interactive *because they're run on computers*. So, how does interactivity exploit the capabilities of the computer? As we saw in chapter 1, digital art takes advantage of the fact that computers

are all purpose representation devices. Computer art takes advantage of the fact that computers are computational processors.

Every art form has a technological foundation, for making art involves some kind of tool. The display of a painting is a marked, patterned surface, and making paintings involves the technology of paint. This isn't a trivial observation: it means that painting can change as its underlying technology changes. The nineteenth-century invention of premixed oil paint in tubes freed artists to paint outdoors, in natural light, and that was a step towards impressionism. In music, the display is a sequence of sounds, which are made using such technologies as musical notation and stringed instruments, and changes in these technologies change the sound of music. Think how the invention of the electric guitar changed music by making distortion a regular part of the musician's toolkit. In the same way, interactivity requires the right tools.

Any computer art work has a display that varies according to its users' actions. Some of these actions must be *significant*. That is, they make a difference to the display. Some of them must also be *prescribed* – the work must be designed for its display to change in response to those actions (which is why spray-painting *The Ambassadors* doesn't make it interactive).

First of all, the work needs an input device: a keyboard, mouse, touch screen, motion detector, camera, microphone, or indeed any kind of sensor. Jeffrey Shaw's *Legible City* uses a bicycle as an input device (fig. 3.3). No matter what form the device takes, it must carry some information from the user. *Boundary Functions* knows where you are and where you've been, *Project X* knows what links you've clicked, and *Telegarden* knows what you ask it to do. (They know these things in the way that your cell phone knows the phone numbers of your friends and acquaintances.) And notice how the input mechanism already marks a break with traditional art. *The Ambassadors*, *Chinatown*, and "My Way" don't collect information on their audience.

Input is one side of the coin; the other is output, a display which changes in ways that can be apprehended by users. Images are commonly used, and text and sound too, but the display can take many more forms besides. It could be a change in the temperature of an environment, for instance. In *Telegarden*, the display is a garden plus a video feed of the garden.

More is needed than an input device and a display: the inputs must relay to outputs. No work is interactive unless some of its users' actions make a difference to its display. Imagine a set-up where you can write comments about a video showing random selections from the American Film Institute's list of Greatest Movie Musicals. The set-up invites input and its display varies,

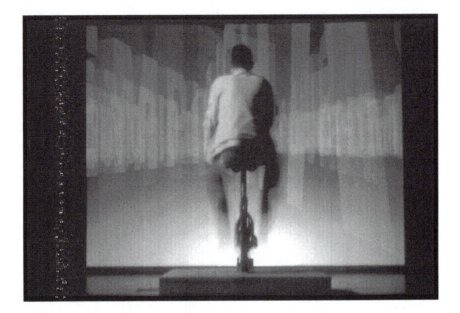

Figure 3.3 Still of Jeffrey Shaw, *Legible City*, 1989

but it's not interactive, because what you write (the input) makes no difference to what you see (the display). In computer art, the display is generated from the input: a path leads from input to display.

For most people, the word "computer" evokes the desktop or laptop computer, but computers are everywhere – in cash registers, TV sets, automobiles, and even vacuum cleaners, just for starters. Notice that not all of these computers display or make representations for us. To cover all the cases, a fairly abstract theory is needed. According to a standard definition in computer science,

> a computer is any item that's designed to run a computational process.

Notice that this theory is functional: it defines computers by what they do, not by the machinery that they use to do it. What's a computational process? According to the standard definition,

> a computational process is any pattern of actions that instantiates formal rules and controls a transition from input conditions to output conditions.[10]

Arranging my collection of business cards in alphabetical order is a computational process that runs in my brain, and the very same computational process is run by the Contacts application on my PDA, though the mechanisms aren't the same. So computers aren't necessarily electronic devices. My PDA is a computer, an abacus is a computer, and the human brain is a computer. All are designed to run computational processes.

To drive the point home, replace the computer science terminology with everyday language. A computational process is a set of instructions usually implemented through a program or software, and a computer is a device designed to run programs. (That includes us. We are designed, in part, to run sets of instructions like the algorithm for long division or the recipe for preparing a soufflé.)

So it's easy to see why computer art works are interactive because they're run on computers. Interactivity requires a mechanism that controls input–output transitions and computers accomplish this by running computational processes. Computer art takes advantage of the fact that computers are things designed to compute.

Of course, interactivity's possible without computers. A beautiful example is Anish Kapoor's *Cloud Gate* in Chicago's Millennium Park (fig. 3.4). As the user steps up to its curved, mirrored surface, she changes the appearance of that surface for a period of time. It's interactive because its display is generated by user input. However, *Cloud Gate* doesn't use a computational process to collect inputs and modify its display. That's done just by means of a physical process, the reflection of light. According to CAF,

> an item is a computer art work just in case (1) it's art, (2) it's run on a computer, (3) it's interactive, and (4) it's interactive because it's run on a computer.

Cloud Gate meets conditions (1) and (3) but not (2) or (4). It's interactive, but it's not a work of computer art.

Computer art, plugged and unplugged

If computers are devices designed to run computational processes, then it follows that computer art works don't have to be run on electronic computers. A mechanical computer or a biological one (a brain, that is) could be used instead. And that raises the question of what electronics brings to computer art.

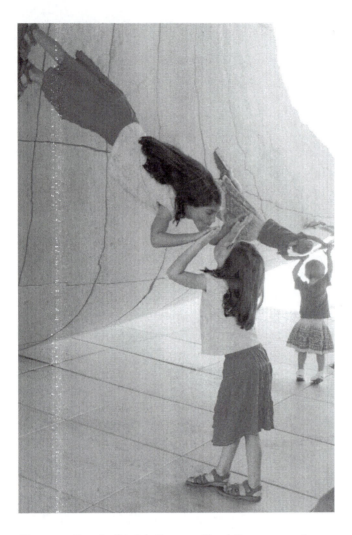

Figure 3.4 Detail of Anish Kapoor, *Cloud Gate*, 2004–6

Imagine a non-electronic version of Daniel Rozin's *Wooden Mirror* (fig. 3.5). The electronic version's display is a grid of 830 small wooden tiles, each one tilted by a small servomotor, so that the pattern of tilted tiles renders an image. On the input side, a camera captures the scene in front of the tiles. Then a computer analyzes the captured image into a grid of 830 pixels, analyzes the intensity of each pixel, and controls the servomotors to tilt the tiles. In this way, the wooden tiles mirror the scene. Now, in *Wooden Mirror Unplugged*, a human operator inspects a bank of 830 tiny etched glass screens

Figure 3.5 Still of Daniel Rozin, *Wooden Mirror*, 1999

onto which light is funneled from the same number of lenses. Next to each screen is a graduated knob which sets an aperture, and the operator adjusts all the knobs until the light intensity is the same across all the screens. He then turns to a second set of knobs which mechanically tilt a grid of wooden tiles, and he adjusts each of these knobs to a marking that matches the marking on the corresponding screen knob. The result is a mirroring by the tiles of the scene in front of them. *Wooden Mirror Unplugged* could have been built long before the invention of the electronic computer.

Is it computer art? Does it fit CAF? Assume it's art. It's obviously interactive. Is it run on a computer and is it interactive because it's run on a computer? The short answer is yes. After all, the human brain is a computer, and the updating of the display requires the brainwork of its human operator. But

this answer isn't entirely satisfactory, because not everything a brain does is a matter of running computational processes. The longer answer specifically addresses the definition of a computer as a device designed to control a transition from input conditions to output conditions *by following formal rules*. *Wooden Mirror Unplugged* is interactive precisely because its human operator manipulates its display by executing an algorithm – by following a set of instructions. So it's interactive because those instructions are executed on a computer, which happens to be a brain. If *Wooden Mirror Unplugged* is art, then it's a work of computer art.

Yet it differs significantly from its electronic cousin. First, it requires a great deal of specialized equipment – a grid of lenses, apertures, screens, knobs, and an indefatigable human operator, in addition to tilting mechanisms and tiles. Apart from the servomotors and tiles, *Wooden Mirror* makes do with an all-purpose camera and desktop computer. Second, and more striking, it's faster than *Wooden Mirror Unplugged*. Only *Wooden Mirror* is fast enough to update the image in real time. Indeed, the unplugged version isn't really a wooden mirror at all.

Until the invention of the electronic computer, interactivity was rare in art. That changed with the availability of inexpensive off-the-shelf input and output units and programmable computers. Moreover, while real-time processing isn't absolutely essential for interactivity, most computer works do display outputs in real time. The point of most computer art works depends on the user's awareness that they're interacting, and a long time lag between input and output inhibits this awareness, whereas real-time response shows the user how her actions lead to changes in the work's display. She can come to know this in other ways – by being told about the set-up, for instance – but real-time processing is direct. For all these reasons, we can see why many of the earliest works of computer art used computers for interactivity.

CAF is built upon a broad conception of computing as computational processing. This conception gives pride of place to electronic computers, which make interactivity an accessible resource of art, but it doesn't assume that all computers are electronic. Thus while paradigm computer art works are run on electronic computers, some are not.

Brain art?

Computer art runs on computers, so if brains are computers then some computer art runs on brains. This reasoning will give you pause if you

reject the assumption that brains are computers; but remember that we've defined computers simply as devices designed to run computational processes, not as silicon circuit boards, and brains are certainly designed to run computational processes. Setting aside any worries about the classification of brains as computers, here's a concern that calls CAF entirely into question. A great deal of interactive art uses brains to achieve interactivity. Is it all computer art?

First a word about what to expect from CAF. Where sharp boundaries separate distinct phenomena, we should seek a theory that draws sharp lines; but when one phenomenon shades off into another, we should expect a theory to represent the kinship between phenomena. CAF does just this: it brings out resemblances between our five paradigm works and other interactive works, without erasing their differences.

The 1960s Happening is often cited as supremely interactive.[11] Likewise, some avant-garde theater theory seems to recommend interactivity as an ideal for theater. Augusto Boal described three stages in the development of participatory theater.[12] Spectators first intervene off stage, perhaps by making suggestions to the actors; then they stage the actors' movements; and finally they join the action of the play. For up-to-date examples, there's contemporary performance art. Over a period of about a decade, Rirkrit Tiravanija put on "performances" in which he cooked dishes for and socialized with his "audience" (fig. 3.6).[13] If this is art, then isn't it computer art? How these works unfold depends on the brain power of the participants, and brains are computers. So is a Happening a work of computer art?

It's not. Participants in a typical Happening are responsible for the way the event unfolds: the work would go differently if they behaved differently. However, no computational process controls the transition from participant action to the work's display. If any process is involved, it's not a computational process.

To explain, let's go back to *Wooden Mirror*. In both its plugged and unplugged versions, a process turns inputs (a person standing in front of a camera) into outputs (an array of tilted tiles). Moreover, this process is computational: it accords with formal rules or instructions; it implements an algorithm. The rules are the same whether they're compiled as code for an electronic computer or written on a sheet of paper as instructions for a human operator.

Happenings typically impose no rules that control how the work goes. A Happening just, well, happens. Put another way, participants in a typical Happening react in a way that's not determined by rules or instructions for

Figure 3.6 Still of Rirkrit Tiravanija, Untitled Performance, 2008

the work. Often the point is to see what happens when they "wing it." I'm hauled on stage at the avant-garde art space and handed an umbrella. I react. I hand it back. My handing it back helps generate the work's display, so the work is interactive, but I don't hand the umbrella back in deference to rules for generating the work's display. On the contrary, I shape the display *no matter what I do*. But I'm not following a rule unless it's possible for me to fail to follow the rule. So while it's true that Happeners have brains and also use them, they don't use them to follow a set of instructions for controlling the work's display based on some inputs. Unlike the operator of *Wooden Mirror Unplugged*, Happeners don't execute a computational process to control how the work's display goes.

One lesson is that not all interactive works that rely on brain power are works of computer art. Works of computer art can be run on brains, but only when brain power is employed to execute a computational process which is responsible for modifying the display based on user input.

A second lesson flows from the first one. Computers often automate processes that were previously done "by brain," and we saw in chapter 1 that they can also automate artistic processes. For this reason, it's tempting

to think that computer art automates what's done by human participants in Happenings and performative installations, and thus that computer art is a simple historical continuation of earlier interactive art. However, this thinking misses an important discontinuity between computer art on one hand and Happenings and performance art on the other hand. Computer art automates the rule-following that generates the work's display, whereas early interactive art rarely involves such rule-following. Computer art resembles early interactive art, but it's not a simple automation of it.

The feature that distinguishes *Wooden Mirror* from *Cloud Gate* also distinguishes *Kodama* from Tiravanija's performance art. *Wooden Mirror* and *Kodama* are interactive because a computational process negotiates transitions from user inputs to display outputs. *Cloud Gate* and a Tiravanija performance are also interactive, and so they have users, who use their brains; but they don't use their brains to execute instructions whose purpose is to control their displays. These users don't compute their displays. That's why *Cloud Gate* and a Tiravanija performance aren't works of computer art.

The open display

Theories are cognitive tools which focus our attention on salient or useful similarities and differences. Their purpose isn't to valorize one kind of art at the expense of another. Computer art, as defined by CAF, takes advantage of computing technology, and so does digital art, as it was defined in chapter 1, but the two theories pick up on different, yet related, conceptions of computers. Moreover, they're not exclusive – some, perhaps even most, computer art is also digital art.

The conception of computers as devices designed to run computational processes is intentionally very broad. According to a narrower definition, computers are universal Turing machines.[14] A Turing machine is a device that scans memory, reads a symbol from memory, erases a symbol from memory, and stores a symbol to memory in accordance with a table of instructions or program. A *universal* Turing machine is a machine that can run any program that any Turing machine can run, just by reading and writing digital symbols to memory.[15] Electronic computers like my Apple iMac are good examples of universal Turing machines (but a universal Turing machine doesn't have to be electronic – Alan Turing first thought of it as a paper-and-pencil device). The essence of the universal Turing machine is computational processing *by digital symbol manipulation*. It's an all-purpose representation device.

This narrower conception of a computer as a universal Turing machine figures in the definition of digital art. Digital art is either made by or made for display by a machine that operates with any kind of information by putting it in a common, digital code. A universal Turing machine is just such a machine. It stores and processes images, sounds, texts, or any kind of representation in a common code. This is a big step beyond traditional representational tools. You can't make a drawing of the Grand Canyon from the F major key or sing "My Way" in oil paint, but you can store them both as computer files in the very same code. Thus computer multimedia also represent a step beyond traditional multimedia. Operas, movies, and comic books combine media without benefit of a common encoding; a QuickTime movie combines images, sound, and text by encoding them all using the same symbol set.

In the broad sense, a computer is a device designed to run computational processes, and a universal Turing machine is one kind of computer. As a result the realms of computer art and digital art overlap. Not all digital art is computer art – most of it's not interactive – but typical computer art is either made digitally or made for digital display. Computer art is free to take advantage of the possibilities of digital art. When it does so, it puts digital technology at the service of interactivity.

After all, interactivity requires nothing more of the display than that it be variable and apprehended by users. Familiar works of computer art may share a look and feel because their makers tend to use available display technologies, such as TrueType text rendering, the LCD monitor, and hi-fi speakers. *Boundary Functions* and *Wooden Mirror* illustrate the range of possibilities for inventing new displays.

Two components of CAF, interactivity and computing, set computer art apart from related artistic practices, especially interactive performances and digital art. So far so good. Computer art is an art kind whose boundaries can be traced in a principled way. The next step is to consider whether computer art is an appreciative art kind. That is, to consider whether we normally appreciate works like *Project X*, *Telegarden*, *Golden Calf*, *Kodama*, and *Boundary Functions* by comparison with each other, for their computer-based interactivity.

4

WORK TO RULE

Novelty is never so effective as a repetition that manages to suggest a fresh truth.

Marcel Proust

Art is for appreciating, and we classify art into different kinds for purposes of appreciation. So a theory of computer art isn't an end itself; it should help explain computer art appreciation. The fact that, if we wish, we can classify together all art made on a Tuesday isn't terribly interesting, and it doesn't matter if some works of art feature computer-based interactivity unless that factors into our appreciations. The next step is to consider whether computer art is an appreciative art kind. Do we normally appreciate works like *Project X* for their computer-based interactivity – for their having variable displays generated by their users?

The Ontological Challenge of Frigidaire Poetry

By definition, the display of every computer art work varies according to its users' actions. In other words, the ratio of work to displays is one : many. *Project X* is one work with many displays. However, there's another way of looking at things: the ratio of work to display is one : one. Users don't generate different displays of the one work; they create entirely new works. Which way of looking at things is right? Does one work have many user-

generated displays, or does each user create a new work? In fact, why does the question matter in the first place?

Project X is a website which anyone can visit on different occasions. Each visitor sees a screen of text and images together with options for traveling to new screens: more than two hundred different screens can be reached by clicking over three thousand links. For all practical purposes, every time someone visits, they see and read a unique sequence of screens. If a sequence of screens adds up to a display, then each visitor generates a new display. Yet the author of Project X identifies it as a single work, not as a collection of many different works. He writes that "though it appears possible to read the work in a more or less linear fashion, the [computer] ensures each reading is unique."[1] If he's right, then one work has many "readings" or displays. But is he right?

After all, computers do sometimes create entirely new works. A nice example is George Lewis's system, Voyager. As Lewis plays his trombone, Voyager "listens" to Lewis, analyzes what he's playing, and generates a musically appropriate response. In this way Lewis and Voyager play duets and create entirely new musical works.

It's fair to ask: when is a computer a device for making entirely new works and when is it a device for generating different displays of a single work? To keep things simple, it helps to think about a tool for making art that's not a computer.

You may own a magnetic poetry kit for your refrigerator door. Some of these kits contain tiles with words printed on them and some have one letter per tile, like Scrabble pieces. Either way, the tiles can be arranged and rearranged into lines of verse. Surely each arrangement of tiles is a distinct poem, and surely the poetry kit isn't a work – it's merely a handy tool for making poems. At least, that seems the right thing to say about the kit with Scrabble-style tiles. William Carlos Williams used the alphabet as a tool for writing his poem, "This Is Just to Say," and Amy Zion used the alphabet printed onto magnets as a tool for writing her reply to Williams (fig. 4.1).

From this comes a challenge to the proposition that Project X is one work with a variable display. Either the magnetic poetry kit is merely a device for generating poems, each being a separate work, or it's one work with many displays. Likewise, either Project X is a device for making poems, each being a separate work, or it's one work with many displays. Unless there's a significant difference between Project X and the poetry kit, we must be consistent in our choice: either both are merely poem-making devices or both are works. We have three options. One is to throw in the towel and

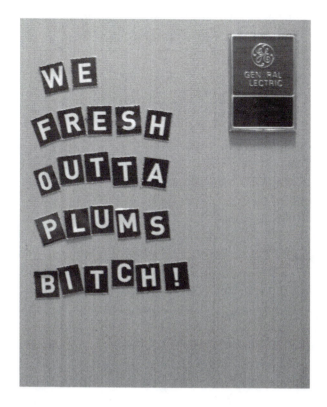

Figure 4.1 Amy Zion, *No Romance After Philosophy*, 2007

concede that *Project X* isn't a work with different displays generated by its users – and neither are *Boundary Functions* or *Kodama*. The second option is to bite the bullet and accept that the poetry kit is a single work with varying displays generated by householders. (Indeed, it's interactive.) Neither option is very attractive. The final option is to have our cake and eat it, saying that *Project X* is a single work with varying displays, but not so the poetry kit. The trick is to pinpoint a significant difference between *Project X* and the poetry kit. The Ontological Challenge of Frigidaire Poetry dramatizes this question: what's the difference between a device for making art and one work with many displays?

Before going on, a word of caution. Why isn't the magnetic poetry kit a work of computer art? One whose interactivity depends on the brains of kitchen poets? Well, it can't be a work of computer art if it's not a work at all, but rather a device for making works. The question to focus on is what's the difference between a device for making works (like the poetry kit) and

a work with many user-generated displays (like *Project X*)? More basically, when do we have a single work with many displays?

Sidebar: music

Many musical works are repeatable – they're performed over and over on different occasions.[2] Moreover, this fact structures our experiences of music. The philosopher Nicholas Wolterstorff writes that, "in listening to a symphony, one hears two things at once, the symphony and a performance of it."[3] We appreciate the symphony alongside its performances. They are two things, both objects of appreciation. A closer look at music might help us to see why *Project X* is also repeatable.

A work of music isn't identical to a performance. Suppose that Schoenberg's 1949 *Piano Concerto* is identical to yesterday's performance at Montréal's Place des Arts. Is it also identical to today's performance of the same sequence of sounds at the Hollywood Bowl? Identity is transitive, so if the *Piano Concerto* is identical to yesterday's performance and it's also identical to today's performance, then the two performances are identical to each other. Yet, as similar as they might be, the two performances aren't identical. I speak no contradiction when I say I've heard one and not the other. More importantly, we listen for the differences between performances. Acoustics vary, conductors render slightly different phrasings, and musicians play in different styles. Since the performances aren't identical and since identity is transitive, the *Piano Concerto* isn't identical to both performances. If it's not identical to both, then it's not identical to either, since there's no reason to privilege one over the other.

You might object that the idea of a "work of music" apart from its performances is an empty abstraction. When it comes to appreciation, only performances matter, not this "work." After all, we appreciate music for its sound, and musical sound is only presented in performances, so all there is to appreciate in music is contained in performances. Nothing is left over to appreciate as the "work" in addition to the performances. Sure, there's the score, but the score is a template for making performances, not an object of musical appreciation.

This reasoning carries over to the magnetic poetry kit. It's not identical to the poems on the fridge unless they're identical to each other, and they're not identical to each other. But that doesn't prove that the kit is an object of appreciation in its own right. Good thing, too, because it isn't. Why not infer that what goes for the kit also goes for the 1949 *Piano Concerto*?

Such an inference has got to be mistaken. If we know anything, we know that the *Piano Concerto* is an object of appreciation in addition to and apart from performances of it.

For one thing, the aesthetic features of the *Piano Concerto* and the performances don't always match. Maybe the performance at the Hollywood Bowl is murky, but the *Piano Concerto* is clear and logical. Indeed, the performance may be especially murky given the clarity of the work itself. And maybe the *Piano Concerto* is coldly logical, even if a particular performance isn't. The *Piano Concerto* is clear and coldly logical only when appreciated in addition to its performances.

More importantly, music fans hear each performance against a backdrop of other performances they've heard or can imagine hearing. Blues fans listening to Elmore James's 1955 "Dust My Blues" are likely to call to mind guitar work on other tunes by Mississippi blues artists in the 1930s. In a similar vein, serious music fans hear performances against the background of other performances *of the same work.* They mentally compare a performance of the *Piano Concerto* with a wide dynamic range to a performance with less range − whether it's a performance they've heard before or just imagine.

This kind of comparative listening is widespread − not at all limited to specialists with advanced musical training and narrow taste in classical music. If you grew up anywhere in the industrialized world during the past thirty years and you hear Cake's rendition of "I Will Survive," then you'll very likely have Gloria Gaynor's hit in the back of your mind. Even if you're not such a person − Gloria Gaynor is news to you − then you still color your experience of the performance with a sense of other possible performances. At least you take into account how poorly the song would work if sung by Bob Dylan, for example.

The lesson is that we appreciate the work by listening to a performance when we appreciate the performance as one among a range of other possible performances, particularly possible performances of the same work (fig. 4.2). Moreover, a music fan who has no clue of other possible performances of a song misses something in the performance she hears. Indeed, she misses something that we normally expect her not to miss. So we get an appreciation of the work as part of fully appreciating its performances.

As a result, the objection that we only appreciate performances of music and not musical works themselves is based on a misunderstanding of what it is to appreciate a musical work. Wolterstorff writes that we hear the work and the performance at the same time, but it might be better to say that we normally appreciate the work by hearing the performance. That is, we normally

Figure 4.2 The spectator or user appreciates a display of a work as one among many possible displays

appreciate a musical work by listening to one of its performances and appreciating it as one performance among many possible performances of the same work. Appreciation of the work is implicit in proper appreciation of its performances.

As any musician knows, the work dictates the features of its performances. A performance of the *Piano Concerto* must have a specified sequence of sounds. In classical music, many of these features are specified in the score, which is a template for performing the work. While there's enough wiggle room for different performers to render different-sounding performances, the wiggle room is limited – no true performance of the Schoenberg *Piano Concerto* sounds exactly like "Stairway to Heaven."

So some features of the *Piano Concerto* cut across its performances – they include being atonal, being by Schoenberg, and being logical. Other features of performances aren't features of the work – such as taking place on a Sunday afternoon, stressing the viola part, and sounding murky. These are features of the performances per se. When you appreciate the work by listening to a performance, you peel away features of the performance per se to get to the features that cut across performances.

The ratio of features of the work to features of the performance per se varies from work to work. As Stephen Davies puts it, musical works can be thicker or thinner.[4] Thicker works specify more features of their performances. Nineteenth- and early twentieth-century classical music is relatively

thick. Thus a great deal of what you hear in a performance of the *Piano Concerto* belongs to the work and not to the performance per se. Most baroque music is thinner, leaving its performances wider latitude. Performers of baroque music choose their instruments and improvise whole stretches of music as well as local ornamentation. Jazz standards are among the thinnest musical works. Although some jazz is on-the-spot composition, most jazz perform-ances improvise on a standard, like "Summertime." The standard provides some basic musical materials – usually nothing more than a melody and chord progression – and any manipulation of these materials in accord-ance with the rules of improvisation is a performance of the standard.[5] Most of what you hear in John Coltrane's "Summertime" are features of the performance per se.

Double appreciation

This detour through music equips us to answer the Challenge of Frigidaire Poetry. Why is *Project X* a single work (like the Schoenberg *Piano Concerto* and "Summertime") and not a device for making new works (like the magnetic poetry kit or Voyager)? What's the difference between *Project X* and the poetry kit?

"Summertime" is a single work with repeated performances because we come to appreciate it in the course of appreciating, for example, Coltrane's performance as one performance among a range of other possible perform-ances that deploy the same musical materials. In general, an item is a work with multiple displays when and only when our appreciation of it is impli-cated in our appreciation of its displays as belonging among its other possible displays.

The reason that the poetry kit isn't a single work is that appreciating it isn't part of appreciating the poems we write with it. The Scrabble-style kit can spell out *any* short poem, and we don't appreciate one of these short poems (e.g. "This Is Just to Say") as alternatives to *any other* short poems ("How Do I Love Thee," "The Road Not Taken") in a way that implicates appreciating the kit itself. That explains why it's merely a device for creating individual works.

Of course, from a certain angle, a Scrabble-style poetry kit can be an object of appreciation in its own right. Imagine a luxury version made of hand-crafted tiles. Suppose they were made by Matisse. We would be quite right to appreciate this poetry kit for its material qualities, for the artistry of the tiles and the bold handling of space and color that's typical

of Matisse. However, this appreciation isn't implicated in appreciating the poems it spells out as belonging among the other poems it might spell out. Put another way, we appreciate it as a work of material design, not as a work of poetry.

Each interaction with Project X generates a sequence of screens – a display – telling a story which may be dull or exciting, insightful or banal. However, Project X isn't identical to any one display, for the same reason the Piano Concerto isn't identical to any one performance. Yesterday you visited Project X and read one display and today you visit again and read another display. Project X can't be identical to both displays unless they're also identical with each other. But they're not identical with each other since they're made up of different words and images telling different stories – perhaps one stresses the courage of the Portuguese explorers and the other stresses the perils of colonialism. If Project X isn't identical to both displays then it's not identical to either, because there's no reason to privilege one over the other.

So, then, is Project X a work in its own right or is it a device for generating works? The question can now be rephrased. It's a work if we appreciate its varying displays as alternatives to each other and are thus led to appreciate the set-up as generating those alternatives (see fig. 4.2). The new question is whether Project X meets this condition. Are we led to appreciate Project X in the course of appreciating its displays as belonging to the range of possible displays that it generates?

Computer art works invite and indeed prescribe repeat encounters. Users expect something new with each interaction and are attuned to the differences between the displays they generate. Through many interactions and displays, they come to see the possibilities the work holds for them. Seeing these possibilities pulls in something that's not available in each display taken by itself. Jay David Bolter envisages the classic hypertext story, "Afternoon," as a diagram of individual episodes with lines representing how each episode leads to others. Each display is a path following the link lines through the episodes. As Bolter observes, "the reader never sees this diagrammed structure: the reader's experience of 'Afternoon' is one-dimensional, as he or she follows paths from one episode to another. Instead the reader must gain an intuition of the spatial structure as he or she proceeds in time."[6] The point is to appreciate the work by intuiting this structure. By interacting with Project X, I help generate a display, a screen sequence which tells a story. Through many interactions, I read many stories, and these suggest the range of stories that the work can generate, whereupon this range of stories reveals something about the

work. I come to see what the author's getting at when he says that "the interconnected nature of this work reflects the fact that the Internet has ushered us into an age of rediscovery, finding out what we already know."[7] Seeing that a sequence of screens celebrating discovery springs from the same materials as a sequence documenting the beginnings of colonial power can make a point about the writing of history not made by either sequence alone.

Project X is a single work if we appreciate its varying displays as windows onto an object of appreciation that underlies them all. We appreciate each display of a computer art work as one of many displays that can be generated through other interactions. By appreciating it as one of many, we look through it to the work.

Works and Games

Project X, Boundary Functions, and Kodama are works whose features differ from the features of their displays. Just as "Summertime" remains dreamy even if a performance of it is merely languid, likewise Kodama is playful even if (indeed because) one of its displays is a little threatening. Since the work and its displays have different features, they're not identical. But, then, what is Kodama, if it's not the same as its displays? The right answer picks up on computer art's unique computational foundations.

In the traditional arts, the displays of repeatable works are generated using "models."[8] Individual examples of Rodin's famous bronze, The Thinker, are cast from a plaster model. Performances of Schubert's song, "The Erlking," are produced by following a score – another kind of model. In each case the model ensures that the work's displays share features in common. Think what it would take for a model to fail to do its job. Pranksters outfit the plaster model of The Thinker with a Groucho Marx mustache and glasses. Now the plaster is no longer a model for The Thinker, though maybe it's a model for Groucho Gets Serious. Or copying errors make a score indistinguishable from the score for the theme music for Bewitched. Now the score fails as a model for "The Erlking."

Models give us a clue to the identity of traditional repeatable works. The work's features include those the model has the job of stamping onto every display. Nothing is an instance of The Thinker if it looks like Groucho Marx instead of a thinker and nothing is a performance of "The Erlking" if it has the melody from Bewitched instead of the melody from "The Erlking." So the properties of The Thinker and "The Erlking" are ones that their displays share

in common – for example, being cast in bronze and beginning with the line "Wer reitet so spät durch Nacht und Wind?".

Note how differently the models for *The Thinker* and "The Erlking" carry out their modeling function. The plaster model ensures that instances of *The Thinker* have certain features because it has those very same features. They come out the right size because it has that size and they represent a man sitting on a rock because it represents a man sitting on a rock. By contrast, the score of "The Erlking" has very few of the same properties as performances of the song. The score is made of paper and ink but not the performances, the performances are sonic events, but not the score, and good performances are harrowing, but not the score. The score functions as a model by *telling* a singer and pianist what to do in order to sound out a display of the song.

The displays of computer art works typically vary wildly from one user to the next. They're "thin" works whose displays share relatively few features in common – most are features of the display per se. Some computer art works might have displays with no intrinsic similarities, or none that are significant. (If we learn about and appreciate a computer art work through its varying displays, then it's not just by seeking similarities but also by attending to differences.) Works of computer art are so thin because their displays are generated by computational processes. In bronze sculpture, the model generates instances because it has some of the very same features that the instances should have; in music, the model generates performances because it tells performers how to sound them out. In computer art, displays are generated under the guidance of a computational process given user inputs. In computer art, the model is a computational process.

In this way computer art is like games.[9] (This will be the first of several similarities between computer art and games, leading up to a much more detailed look at video games in chapter 7.) Games are interactive: the actions of two people playing chess determine the course of the game. Moreover, practically every game of chess is different. They don't share the same sequence of board positions. Nevertheless, all playings of chess are playings of the same game. The reason is that playings of chess need only conform to the rules of chess.

Tic-tac-toe (or noughts and crosses) has rules simple enough that we can easily represent each playing. A playing of the game unfolds in time and consists in a succession of states. Each state can be represented by three ordered triples, one for each row, whose values indicate whether each of

the board's nine squares contains an X, an O, or is empty. Each of these states is determined by earlier states of the game plus the rules and a player's choice. Together with the rules, it also determines possible later states of the

```
<<X, O, X>,
<empty, empty, empty>,
<empty, empty, O>>
```

game. In other words, the current state of play determines what moves a player may make while still playing the game. A playing of tic-tac-toe is any sequence of states, each of which complies with the rules. The game itself is the item whose playings are sequences of states that comply with those rules.

Tic-tac-toe is so simple that there are a small number of possible playings, but many games, like chess, have huge numbers of possible playings – they can progress through huge numbers of state-sequences. Obviously, this is a merit of games worth playing. Not only does the play unfold according to the players' actions, but there are so many possible playings that we can only come to appreciate the qualities of the game itself by appreciating some of its many possible playings as playings of that game.

Computational processes in computer art are like the rules of games. A display of a computer art work is a sequence of states. Each state in the sequence is determined by previous states, user input, and the computational process that transforms inputs into outputs. Like playings of a game, each display sequence of a work is practically unique, so long as the work is sufficiently complex. But although users can generate many distinct displays, they are generated by the same computational process. The work itself is, at least in part, the item whose possible displays are generated by that computational process.

Programming computer art

This idea finds an echo in the common identification of some works of computer art with computer programs. As a practical matter, this identification makes sense, though a computational process isn't precisely the same as a computer program.

First, one computational process can be implemented in different programs. For example, adding numbers is achieved by a computational process which many different computer programs accomplish. They may

be written in different programming languages (Basic, Pascal, or C) or for different operating systems (Unix or Windows) or for different chips running the same operating system (Power PC or Intel Macs). Similarly, a computer art work might exploit a computational process run by different programs – maybe it has Unix and Windows versions. What it can't do is run a different computational process.

More importantly, since computer programs handle input and output in a common format (e.g. binary code), they're blind to the type of data that come in as input or exit as output. In principle, you can get your computer to display audio files as text and text files as video (this takes a little hacking because computer makers don't want you to see gobble-degook or hear noise.) By contrast, computational processes work with designated types of data. A computational process which orders a list alphabetically works only with linguistic text, and a computational process for red-eye reduction works only with images of faces. The computational process that runs *Wooden Mirror* takes a video image as input and outputs a two-dimensional image in wooden tiles. The *program* running *Wooden Mirror* could be hooked up to an email server for input and a pair of speakers for output, but it would just make a lot of noise, and that's no longer *Wooden Mirror*. The reason isn't that the program has changed. It's the same! Rather, the work isn't *Wooden Mirror* because that program no longer runs the right computational process.

The identity of a work of computer art reflects its computational foundations. Its varying displays are generated under the control of computational processes, and we appreciate it as such. Just as chess is the game whose instances follow a certain set of rules, *Boundary Functions* is, at least in part, the work whose displays spring from a certain computational process.

Material matters

A dogma of twentieth-century modernist art theory was that correct appreciation of a work must restrict itself to features that are entirely unique to its art form.[10] In the case of computer art, that feature is interactivity achieved through computational processing. So the dogma implies that we should appreciate computer art only for what it does with computational processes. While many works of computer art have a material side – little wooden tiles, for example – the dogma directs to ignore these material accouterments. However, the modernist dogma is untenable. The material side of computer art matters.

As we've seen, the identity of a work is implicit in sound appreciations of it. Thus, one way to get at the identity of a work is to consider what sets it apart from copies or forgeries of it, assuming that we don't appreciate a copy or forgery as we appreciate the original.[11] *The Ambassadors*'s display is a two-dimensional pattern of shapes and colors that we apprehend in appreciating it, but the painting is more than that pattern. After all, a perfect copy with exactly the same display pattern isn't *The Ambassadors* itself. So what is there to *The Ambassadors* apart from its display? What is there to the original that's missing in the copy? Perhaps the original is that display plus the very paint and wood that the display is made of. A copy is a different work because it's not made of the very same matter. Another suggestion picks up on the fact that the painting was made by Holbein. The copy isn't by Holbein, and that's why it's a different work. Of course, these two suggestions are compatible: maybe the painting is a certain display made by Holbein out of those very bits of paint and wood. How do we decide among these and other options? Only by consulting the practice of appreciation. Does it make a difference to appreciation what paint and wood the display is made of? Does it make a difference to appreciation whether the display is made by Holbein or someone else?[12]

Assume that a work of computer art is nothing more than the item whose various displays are delimited by a computational process. Suppose I replicate the set-up of *Wooden Mirror* and reverse engineer the computational process that runs it. If my system runs the same computational process then it has the same range of possible displays, so if *Wooden Mirror* is identical to anything that has those possible displays, then my mock-up is *Wooden Mirror*. I can legitimately tout it as *Wooden Mirror* in my local Interactive Art Space; I can help myself to a piece of Daniel Rozin's limelight. If your reaction is that I've lost my mind and the truth is that, at best, I've copied or forged *Wooden Mirror*, and my mock-up isn't the original *Wooden Mirror*, then there must be more to *Wooden Mirror* than a computational process. Our starting assumption was wrong.

One possibility is that *Wooden Mirror* includes its physical apparatus, certain bits and pieces of matter. Not every bit and piece. Replacing the extension cord probably wouldn't change the identity of the work, for it would probably have no impact on our appreciation of the work. What about replacing its tiles? It's a safe bet that no fixed rules determine what bits and pieces are essential to any given computer art work; we must examine the details of each case.[13]

At any rate, this proposal doesn't cover every case. *Boundary Functions* hasn't always run on the same physical apparatus so its physical bits and

pieces are interchangeable, not essential to it. It's still wrong to treat my mock-up as *Boundary Functions* itself. Here we can opt to identify the work by its connection to its maker, Scott Snibbe. Maybe the work is the item whose varying displays come from the right computational process using equipment assembled for that purpose by Snibbe or his designates. Since I'm not Snibbe and he hasn't authorized me to act in his place, my mock-up isn't *Boundary Functions*.

Some computer art is designed to run on a wide variety of equipment. *Project X* has run on several different servers and it can display on any computer with an Internet connection and a standard web browser. So maybe *Project X* is the item whose displays are generated on standard web browsers by a certain computational process, which is implemented in code that's written by its maker and runs on servers at his blessing. A work with the same possible displays generated by the same computational process and coded by someone else isn't *Project X*. The real *Project X* has a provenance tracing back to its maker.

Does the history of a work make a difference to our appreciation of it? "Summertime" was written by Gershwin in 1935. Many would agree that a song with the same sonic structure written by Tom Waits in 1995 would have radically different aesthetic features – it might parody the nostalgia that Gershwin salutes. The same may be said for computer art. Imagine a computer art work made in 1965 that comes across as technologically bold. A work that runs the same computational process but was created in 2005 might mock the old technology or trumpet a return to fundamentals. History makes a difference to appreciation if a work's provenance is part of its identity.

Material matters, but the core remains computer-based interactivity. That's what sets computer art apart from other kinds of art. So we appreciate computer art works for what they are when we appreciate them for their varying displays generated through computational processing – when we appreciate them for the possibilities they represent, some of which we help to realize. Indeed, by helping to realize them, we learn what the possibilities are and hence appreciate the work itself. The next chapter builds onto this idea by looking into our actions as users.

5

ARTIST TO AUDIENCE

The ideal ratio of artist to audience is zero to one.

Glenn Gould

There's more to art than sitting around and looking pretty. Art works are opportunities for action, and their value depends on the tasks they afford. First comes creative activity, then sometimes performance, and finally appreciation, which includes looking, listening, reading, interacting, interpreting, liking, critiquing, and much else besides. In so far as each of these tasks calls up different skills, they get assigned to specialists: artists create works, performers perform them, and audiences appreciate them. As natural as it may sound, though, some deplore this division of labor between artists, performers, and audiences. John Cage complained that music "has consisted ... of people telling other people what to do, and these people doing something that other people listen to." His own goal, which he admits he never reached, was to "create a situation in which no one told anyone what to do and it all turned out perfectly well anyway."[1] This comes close to describing computer art, where interaction folds in elements of creation, performance, and appreciation.

Roles in situations

Situations call for tasks to get done and thus for people to do them. For example, education is a situation of teaching and learning and hence teachers and students. The art situation calls for acts of creation, performance, and appreciation on the part of artists, performers, and audiences. At least, that's the situation for traditional art forms like painting, architecture, poetry, dance, and music. Many see computer art as revolutionizing the traditional art situation by blurring the lines between artist, performer, and audience.

One commentator declares that "the position of the Kantian aesthete is no longer valid: you cause the work and co-produce it with the artist."[2] The computer art pioneer, David Rokeby, writes that "the audience becomes creator in a medium invented by the artist. The artist enables the interactors to express themselves creatively."[3] Myron Krueger, another pioneer, describes computer art as "a unique melding of aesthetics and technology in which creation is dependent on collaboration among the artist, the computer, and the participant."[4] Roy Ascott agrees: "creativity is shared and authorship is distributed."[5] This passage nicely sums up the thinking:

> For at least several centuries, in the West, the artistic phenomenon has presented itself as follows: a person (the artist), signs a particular object or message (the work), which other persons (the recipients, the public, the critics) perceive, taste, read, interpret, and evaluate ... The techno-cultural environment that is emerging, however, gives rise to new art forms, ignoring the distinction between emission and reception, creation, and interpretation ... This new art form allows what is precisely no longer an audience to experience other methods of communication and creation.[6]

How much truth lies in statements like these?

Structurally, the traditional art situation is much like communication. The philosopher Gary Iseminger defines art as (in part) a practice where there's a communicative transaction between two people mediated by a work that one produces for the other.[7] An artist creates a work for an audience to appreciate, just as, in communicative situations, a sender creates a message for a receiver to interpret. The analogy nicely fits works like paintings. Manet created *Woman with Parrot* to be appreciated by you and me, and the painting links us to Manet (fig. 5.1). A little tweaking is needed for performance works like "Summertime." Gershwin composed this song for others to perform and for us to appreciate through its performances, which

Figure 5.1 The artist (*top left*) makes a work for appreciation by a spectator (*bottom*)

Figure 5.2 The composer (*top left*) makes a work, the performer (*right*) makes a performance of the work, and the listener (*bottom*) appreciates the work through the performance

link us to Gershwin (fig. 5.2). A longer chain links us to Gershwin than the chain linking us to Manet, but communicative chains also have many links when messages are relayed by intermediaries.

Notice that the communication model of the art situation already blurs the boundaries between artist, performer, and audience. In communication, senders of messages regularly trade places with receivers: A sends a message to receiver B and then B sends a message back to A, and so on. Anybody may send and receive messages. Likewise, artists, performers, and appreciators aren't discrete populations: they're roles, and one person can switch from role to role.

Art culture in the West is now so specialized that very few adults ever create or perform art works. For the most part, only specialist composers and performers (and children) write and perform music, and only specialist artists (and children) make paintings. Moreover, when a medium is widely used by non-specialists, we're apt to reserve art status for works made by the specialists. For example, most people take photos, but we only count artists like Diane Arbus and Andreas Gursky as making art. It sounds absurd to say that just anybody who takes photographs is an artist.

However, this specialization of the art situation is an exception in human history. In many cultures, almost everyone makes and performs art. The psychologist Daniel Levitin tells a story about the anthropologist Jim Ferguson, who lived among the Sotho in southern Africa. The villagers had just invited Ferguson to sing, and he gently declined:

> Jim knew that he wasn't much of a singer or dancer, and to him, a public display of singing and dancing implied he thought himself an expert. The villagers just stared at Jim and said, "What do you mean you don't sing? You talk!" Jim [said] later, "It was as odd to them as if I had told them that I couldn't walk or dance, even though I have both my legs."[8]

Ferguson's villagers don't regard making and performing art to require the expertise of a virtuoso. For them, almost everyone is an artist and performer.

A notorious feature – some would say failure – of the contemporary Western art situation is that it even makes a specialty of appreciation. Only those given a formidable education in art history and theory are expected to appreciate recent "high art" or "serious art" – Robert Rauschenberg's paintings, Arnold Schoenberg's atonal compositions, Thomas Pynchon's novels, and the like. Ordinary Joe is outside the audience for such art as this. Again, this is a peculiarity of the contemporary West. Most other cultures set lower demands on appreciation and open up membership in the audience to all comers.

Outside the Western high art scene, many people take on all the tasks needed in the art situation – creation, performance, and appreciation. This isn't to criticize the Western high art scene. The point is simply that we cannot generalize from a special feature of one art situation to others. In many art situations, one and the same person is an artist, performer, and appreciator – just as, in communication, one and the same person is often speaker and listener.

The lesson isn't that it's time to give up on the distinction between artist, performer, and appreciator; the lesson is that these aren't different people, but different roles instead.[9] In conversation, you alternate playing the role of sender and receiver. One person, two roles. In just the same way, artist, performer, and appreciator are roles rather than discrete populations. One person can assume different roles, unless the demands of specialization preclude playing multiple roles.

Your actions in playing the role of artist aren't the same as your actions when you play the audience role, so it makes sense to define each role in terms of the actions that belong to playing the role. This leaves room for overlap. Both making and appreciating a painting normally involve acts of looking, so the roles of picture maker and picture appreciator involve some of the very same activities. Nevertheless, the roles aren't identical if some of the activities that are involved in making differ from some of the activities that are involved in appreciating.

The artist

The role of artist is defined by the activity of art-making. What activity is that?

One strategy is to make a list. Henri coats a canvas in gesso, fills a bowl with fruit, looks at the fruit, sketches, squeezes paint from a tube, and lays down blobs of paint. Joni picks on a guitar to find a catchy tune, jots down the tune, tries out a chord sequence to highlight the tune's expressive character, and sets lyrics to a couple of measures. Each of these activities results in a work of art, but the listing strategy hides what they share in common.

A better strategy draws up a general description of "artistic activities" – those that define the role of artist. Since some works of art are made through collaboration, the same description should tells us why some collaborators help make an art work. Joel and Ethan Coen collaborate, with Joel directing and Ethan producing movies (more or less). Did they both make Blood Simple, one by guiding the cast and crew in committing a screenplay to film, the other by hiring the cast and crew, finding locations, and raising funds? Frances McDormand plays the role of Abby in the movie. Did she also make it? What about the gaffer's lighting set-up and the key grip's wrangling the technical equipment? Then comes the projectionist screening the movie in a cinema. Should she get artistic credit?

It's often useful to simplify by taking art out of the equation, so consider the activities that define the role of a "maker" in general. For example, in making a hockey stick, you take some lumber and give it the right shape. This is part of making the stick because it makes a difference to the features of the stick.[10] The rule is that

> an action counts as making a whatsit only if, were it not for the action, the whatsit would not have some of the features it has.

Obviously, your cooking an omelette has nothing to do with making the stick if it makes no difference to its features. From this triviality, it's a short step to the start of a description of the whatsit-maker role:

> a person plays the role of whatsit-maker in doing an action only if, were it not for the action, a whatsit would not have some of the properties it has.

Whatsit-makers make a difference to the features of whatsits.

This isn't the whole story. Suppose you coat the blade of your hockey stick in epoxy which is made by Alice in a distant factory. Were the epoxy different, the stick would have different features, but Alice doesn't play the role of stick maker. Why not? Perhaps because making epoxy isn't an activity that defines the role of hockey-stick maker? But that can't be right. There's more to making hockey sticks than shaping wood, and if you had made your own epoxy for the hockey stick, then your activity would have been part of playing the role of hockey-stick maker.

The solution is that we normally make things intentionally. Not always, for someone might make a hockey stick by accident, but a person who always makes hockey sticks purely by accident doesn't play the role of hockey-stick maker. They play that role only in so far as they intend to make hockey sticks. So the activities defining the maker role are intentional:

> a person plays the role of whatsit-maker in doing an action just in case the action is done with an intention to make a whatsit and the whatsit wouldn't have some of the properties it has were it not for the action.

This solves the problem of Alice. True, the hockey stick would have been different were it not for the epoxy she made, but she didn't make it intending to make a hockey stick, so her contribution doesn't make her a hockey-stick

maker. At the same time, you're a hockey-stick maker if you make the epoxy intending to make a hockey stick.

The artist is a special kind of maker, an art maker. Manet played the role of artist when he painted *Woman with Parrot* because his actions shaped the painting's features and were done intending to make the painting. Those who made the paints he used also shaped the painting's features, but they didn't intend to make the painting, so their contribution doesn't make them artists. Applying the description of makers to art makers,

> a person plays the role of artist in doing an action just in case the action is done with an intention to make a painting, song, poem, or ... and the work wouldn't have some of the properties it has were it not for the action.

The principle also helps with cases like *Blood Simple*. The making of the movie included actions by both Coen brothers, McDormand, and the gaffer, but not the key grip or the projectionist.

Why not the projectionist? Presumably, her actions make no difference to the features of the movie. But what if she spills popcorn in the film gate of her projector, making the screening look different? And what if she does this intentionally – she wants to experiment with the look of the screening. It follows that her actions make the screening, yet she doesn't make the movie. To solve this puzzle, recall the previous chapter. Our projectionist gums up the movie's display but she doesn't gum up the movie itself, because the movie isn't identical to its display.[11]

In sum, a person plays the role of artist when and only when they act intending to make a work in an art form, with the result that the work wouldn't have some of the features it has were it not for their action. Any specific action can count, so long as it meets these two conditions. Chipping at stone, writing a score, throwing clay, editing tape, screaming, sitting quietly in a room, writing code in C++ ... any of these may count as artistic activities.

Those who proclaim the death of the artist think of him or her as determining single correct interpretations of their creations.[12] On that view, there never have been any artists. That suggests we need a better definition of the artist role, which distinguishes artist from audience. T. S. Eliot did something in writing "The Wasteland" that no reader can do: he selected and arranged the words of the poem. Not so for any reader, even readers who play around with its meaning. In a way, readers are makers – they

make interpretations of art works. But only artists make works for readers to interpret.

A final question. Making a work with multiple displays isn't the same as making its displays. Does this mean that artistic activities exclude making its displays? Beethoven wrote the "Große Fugue." Does he collaborate with the Tokyo String Quartet in their performance of it? The question divides in two. First, would the performance have had some different properties were it not for Beethoven's compositional action? Well, yes! If Beethoven had put in more notes, the Tokyo Quartet would have played more notes. Second, did Beethoven compose the piece intending to perform it with the Tokyo String Quartet? Of course not. So while his artistic activity runs to making the "Große Fugue," it doesn't run as far as making its performances. No matter. Every performance depends on what he did because every performance would have been different were it not for his compositional act; and that's a kind of half-authorship for which he gets some credit.[13]

Computer artists

Every artifact is made by someone, including works like Golden Calf and Boundary Functions, so somebody does something that brings these works into being. That would typically be a computer artist. (They're not made by someone playing the artist role when they're made accidentally.) What activities go into playing the role of computer artist?

An answer should build on the lessons of the previous chapter. A computer art work is the item that has various possible displays, and it's appreciated through these displays, as they are generated with the help of users, by a computational process and some physical apparatus. Computer artists build the systems that allow the work's displays to be generated in this way.

For example, Snibbe played the role of artist in making Boundary Functions. Boundary Functions uses an algorithm that draws Voronoi tessellations, and Snibbe wrote the code implementing the algorithm as a subroutine of the work's computational process. He also built the physical apparatus in which user interactions take place. By writing this code and building this environment, he acted on an intention to make the work, and Boundary Functions would have had different features otherwise. Suppose he built the platform out of a bed of jello instead of wood, or suppose that instead of using an algorithm for drawing Voronoi tessellations, he used an algorithm to draw hexagonal tiles like a honeycomb. The end result would have been significantly different.

Does he also play the artist role in making its varying displays? The question divides in two, as we learned from the case of Beethoven's work with the Tokyo String Quartet. First, would the display you generate when you interact with *Boundary Functions* have had some different properties were it not for Snibbe's artistic actions? Obviously, yes. Second, did Snibbe make the work intending you to generate that display? Probably not. Technically, then, his activities as a computer artist don't include making the displays, even though they would have been different were it not for his actions.

Computer artists are like other artists. True, the specific actions associated with the role of computer artist differ quite a lot from the specific artistic actions of painters, poets, architects, and composers. None of these artists work with function calls, compilers, or interface drivers. However, it's to be expected that the specific actions that go into making works in any art form reflect the nature of that art form. What Manet *specifically* did in making *Woman with Parrot* is no more different from what Yamakawa *specifically* did in making *Kodama* than it is from what Eliot *specifically* did in writing "The Wasteland." Specifics aside, they all did the same sort of thing.

Those who see computer art as blurring the boundary between artist and audience can easily accept this conclusion. They say: of course computer art works are made by artists, but the interesting point is that their users aren't just the audience – they're artists too. The question to ask isn't so much whether Snibbe is an artist for making *Boundary Functions*. The question is whether its users also play the role of computer artist by generating its varying displays.

Bluntly, the answer is no. The actions of computer art users don't meet the two conditions defining the role of computer artist. My interacting with *Boundary Functions* involves me in lots of specific activities – bodily and cognitive. However, I don't do these actions with an intention to make *Boundary Functions*. If I have a little savvy, I may intend to generate a *display* of the work through my actions; but the work isn't the same as its display and an intention to generate a display isn't an intention to make the work. Moreover, the work would have exactly the same features no matter what I do to generate its display. While that display wouldn't have the same features were it not for how I act, the work, once again, isn't the same as the display I generate. Nothing I do creates the computational process or physical apparatus, so nothing I do creates the work (fig. 5.3). Consequently, I don't do anything qualifying me for the role of computer artist.

You might retort: look, the one thing I'm sure of is that these new works do change the relationship between the artist and the audience. They create

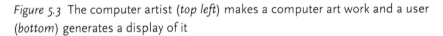

Figure 5.3 The computer artist (*top left*) makes a computer art work and a user (*bottom*) generates a display of it

a new kind of art situation. The only way to explain this is to say that we should broaden our conception of artistic activity to include what users do. From that it follows that computer artists aren't like traditional artists, and it's a mistake to treat them as the same. Fair enough, unless there is another way to explain how computer art changes the art situation. Here's a possibility: computer art has a new kind of audience.

Computer art users

The computer art situation is new and unfamiliar exactly because it brings in computer-based interaction. Computer art works have users, whose role is unlike that of a traditional audience. As Michael Rush observes, "viewers are essential, active participants in this art. No longer mere viewers, they are now users. We have come a long way from passive viewing of the *Mona Lisa*."[14] What does this mean? What activities set the role of user apart from the role played by members of traditional audiences?

The contrast between the new computer art audience and audiences of old is easy to exaggerate. Rush describes the latter as "passive" – and he puts the point more mildly than some others. Augusto Boal championed an avant-garde theater based on the premise that "the spectator is less than a man and it is necessary to humanize him, to restore to him his capacity of action in all its fullness."[15] Such talk woefully underestimates the work that

goes into being a spectator (see chapter 3). Spectators look, listen, read, and feel. They also interpret, and let their interpretation seep into their experience of the work. Since interpretation usually aims to put a work in the best possible light, evaluation comes in too. All these activities feed into the bigger task of appreciation, which is the characteristic task of any audience member. Why put audiences down as "passive" when appreciation can be so strenuous?

Giving traditional art spectators their due still sets them apart from computer art users. Users do something that traditional art audiences don't do. Through their actions, they generate displays of works. More importantly, they appreciate works by generating those displays. Traditional audiences experience, interpret, and typically evaluate works, but they don't carry out these tasks by generating their displays. That power's reserved to computer art users.

Users and performers

Granted that the user is neither artist nor traditional audience, why not identify her with a performer? The composer Rainer Linz writes that,

> "interactive" when applied to music performance can be problematic because in a broad sense, music has always been an interactive art. We could describe any musical performance as a process of real time control over a complex system (instrument), through gesture and based on feedback between performer and machine.[16]

Perhaps the user who generates a computer art work's display is more like a cellist than a tourist visiting the Louvre.

This proposal is especially serious because it threatens CAF.[17] According to CAF

> an item is a computer art work just in case (1) it's art, (2) it's run on a computer, (3) it's interactive, and (4) it's interactive because it's run on a computer.

Remember that a work is interactive just in case its users generate its displays. So if a keyboardist who performs "Brazil" is a user, then "Brazil" is interactive and clause (3) is satisfied. We'd better grant (1). That leaves (2) and (4). Does the keyboardist generate a performance by running a computational

process? Yes, if playing from a score is a matter of rule-following. So all scored music is computer art! CAF fails hopelessly to distinguish computer art from other art. For the sake of CAF, it had better turn out that users aren't performers.

Users and performers share something in common: they generate displays of works. Yo-Yo Ma performed Bach's fifth cello suite on several occasions and Sir Laurence Olivier famously performed *Hamlet* on film in 1948. However, the roles of performer and user aren't the same just because they involve overlapping activities. The roles are the same only if they involve identical activities. Is there more to performing than generating displays?

Imagine that Stephanos, a three-year-old, just happens to bang out a sequence of sounds matching the fifth movement of John Cage's *Suite for Toy Piano*. He generates a display of the movement, but is he a performer? Certainly not. For one thing, he's not trying to perform the movement, and performers act intentionally. Stephanos pulls off an accidental performance of the movement. But intention alone isn't enough to play the performer role. Stephanos must know what sonic features his performance must have if it's to be a performance of the movement, and he must use this knowledge in playing his piano. Thus his intention isn't merely to perform the movement, but to perform it by making these sounds − the sounds that performances must have if they're to be performances of the movement. Packaging this together:

> a person plays the role of performer in generating a display of a work only if he or she (1) generates the display (2) as a result of knowing what features it must have in order for it to be a display of that work and (3) with an intention to generate a display which has those features.

Stephanos doesn't play the role of performer when he bangs out the fifth movement of Cage's *Suite*, for he doesn't do (2) and (3).

As complex as this theory may seem, it's the bare minimum, the first step towards a full theory of performance. Three complications are worth pausing over.

One is that performances are often collaborative. Does Olivier perform *Hamlet*? Not exactly. He performs his part (the role of Hamlet) but not the whole play. The play is performed by the whole company, which collectively knows its features and collectively intends to put on a show with those features, thereby generating a display of the play. Olivier helps to perform the play only if he generates a part of the play as a

result of knowing that part and intending to generate a part that realizes what he knows.

Second, performers normally do more than what's required to generate a display with the required features. Ma plays the right notes in the right order, but he also has an interpretation of the work and he plays in a way that conveys his interpretation. The more interesting the interpretation, the better the performance, all else being equal. However, a heavy-handed, numbskulled performance that does no more than hit the right notes in the right order is still a performance.

Finally, performers are themselves parts of their performances. Recall our movie projectionist, who's already had it explained to her that she doesn't get artistic credit alongside the director and the set designer. Is she a performer? She generates a display of *Blood Simple*. Suppose she knows how the screening goes and intends to generate a screening with the required features. If she doesn't perform *Blood Simple*, then why not? The answer is that she's anonymous: we don't attend to the screening as one that *she* generated. By contrast, Ma and Olivier are anything but anonymous. You appreciate the fifth cello suite by hearing it performed and you hear it performed by hearing Ma perform it. Likewise, you appreciate *Hamlet* by seeing it performed and you see it performed by seeing Olivier and his company perform it.

Adding to our formula:

> a person plays the role of performer in generating a display of a work only if he or she (1) generates the display (2) as a result of knowing what features it must have in order for it to be a display of that work and (3) with an intention to generate a display which has those features, so that (4) an audience attends to the work partly by attending to his or her doing (1), (2), and (3).

Olivier generates a display of *Hamlet* which is shaped by an intention to help perform the play in accordance with his close reading of it. Audiences watch him saying the lines in a way that reflects his reading and thereby they attend to the performance and the play. In a nutshell, performers perform for an audience.[18] Our ambitious projectionist isn't a performer in this sense.

Users aren't performers because they don't do (2) and (3) – and hence they don't do (4) either. That is, they don't generate displays intending them to have certain features which they know they must have. Ma begins with a knowledge of what Bach's fifth cello suite should sound like and then he tries to perform it accordingly. Users of *Project X* don't know what properties

its displays must have and so don't try to generate displays accordingly. This point brings out two interesting features of user interaction.[19]

To begin with, users don't have to rely on their knowledge of a work in order to generate displays, because they have a resource that's not available to performers. A computer running a computational process automatically generates displays for the user when given input. In a way, it knows for the user what the performer has to know for herself. This comes across clearly when users collaborate. When performers collaborate (in putting on a play, for instance), they collectively know what features their performance should have and they collectively intend to make a performance with those features. Not so when users collaborate, as they did in maintaining *Telegarden*. Instead, they collectively rely on a computational process.

Whereas performers depend on their knowledge of a work to generate a display, users aren't so dependent. As a result, they may explore the work in a way that performers can't. Performers might explore different interpretations of the work, but only if they know the work. Users must explore the work itself, by generating different displays of it, before they're in any position to interpret it. Performers know the work and figure out its significance; users must figure out the work by generating its displays. So both users and performers engage in exploratory interpretation, but only users explore works themselves simply by generating their varying displays. That's why they're often surprised at what transpires.

Another way to bring out the contrast between performers and users is to look at what each achieves. A performer's achievement consists in knowing the work, using that knowledge to formulate a performance plan, and executing the plan to generate a display of the work for an audience. The user's achievement is to generate displays of a work, learning enough from each new display so as to discover the work.

None of this implies that it's impossible to perform computer art works. Someone who knows *Project X* very well – a long-time user – might be in a position to use her knowledge to generate displays with certain features. In doing this, she'd play the role of performer rather than user. However, this mode of engagement with computer art is rare, if it occurs at all. On one hand, this suggests that as users come to know computer art works better, they begin to take on the performer's role. The roles shade off into one another, and nothing prevents one person from playing both roles. On the other, this underscores the difference between user and performer.

Getting into it

Contrasting users with performers highlights what's special about the user role. Users don't meet conditions (2) and (3) of the theory of the performer role. Instead, they rely on a computational process that automatically generates displays of a work, leaving them free to explore the work. Since they don't meet (2) and (3), they can't meet condition (4) either. But although users aren't performers, they do seem to share this characteristic with performers: they generate displays for an audience, if only for themselves. If that's right, we need an analogue of (4) for the user.

Some historians trace the ancestry of computer art to 1960s Happenings and mid-twentieth-century avant-garde performance art and theater. Here Allan Kaprow describes one of his Happenings:

> Everybody is crowded into a downtown loft, milling about, like at an opening. It's hot. There are lots of big cartons sitting all over the place. One by one they start to move, sliding and careening drunkenly in every direction, lunging into one another, accompanied by loud breathing sounds over four loudspeakers ... Suddenly, mushy shapes pop up from the floor and painters slash at curtains dripping with action. A wall of trees tied with colored rags advances on the crowd, scattering everybody, forcing them to leave.[20]

Okay, it was the 1960s. Anticipating the 1960s, Jean-Jacques Rousseau imagined spectacles sponsored by the French revolutionary authorities. "What will be the subjects of these entertainments? What will be shown in them?" he asked. "Nothing, if you like ... let the audience be their own play; make them actors themselves, each seeing himself and loving himself in the other so that they all come closer together."[21] Events such as these sought to dispense with the artist and elevate the spectator to performer.

Participants in Happenings aren't performers like Olivier and Ma, but they do bring out an ingredient of the performer's role. Performing involves having an idea of the work and performing to achieve that idea, so that a performed work isn't identical to the performers and what they do. In a Happening, the work is just the Happeners and what they do, and what they do doesn't include anything like generating a display from knowledge of a work. Nevertheless, Happeners and performers are, each in their own way, objects of audience attention. When we listen to Aretha Franklin doing "Chain of Fools," we hear her singing and we appreciate the song by hearing

her singing. Likewise, when we watch Kaprow doing his Happening, we see him Happen away, and we see the Happening by seeing him Happen. What Happeners do is make up the work as they go, and the audience attends to that. What performers do is intentionally generate a display based on knowledge of the work, and the audience attends to that too.

Are any of the user's activities done for an art-appreciative audience? Do audiences attend to what users do, where part of what users do is marked for the attention of their audience? (Remember, the user and the audience are roles, so they can be occupied by one and the same person.)

You walk into *Kodama* and it echoes your voice back at you. You've generated a display of *Kodama*. You haven't performed it because you don't generate the display by using knowledge of what features the display must have. On the contrary, you may know nothing about the work except what you learn by interacting with it. But just as performances include performers, the display you've just generated includes you, through a bit of voice capture. You try to understand it partly by considering the effects of your actions.

Consider how different this is from using a playback mechanism like a CD player. You slip the CD into the player and push the play button to hear "Chain of Fools." Playback isn't performance. First, pushing the play button plays the song in a way that doesn't require that you know the song. Even if you do know the song, that's not why it sounds as it does. Second, no audience appreciates "Chain of Fools" by attending to your pushing play (you're as anonymous as a movie projectionist). It would be silly for someone to say they only really got "Chain of Fools" once they heard the way you pushed play.

Some things we do with computers are like playback – we use buttons and menus to control text, music, and video streams. (Unfortunately, sometimes these actions are touted as "interactive."[22]) Interacting with computer art isn't akin to playback. What's missing is an ingredient that true interaction shares with performance and also with Happenings. The user's actions are part of the display that she generates.

Putting this all together, we can list the activities that go into playing the role of computer art user:

> a person plays the role of user in generating a display of a work only if he or she (1) generates the display, (2) exploring the work, so that (3) an audience attends to the work partly by attending to his or her doing (1) and (2).

Figure 5.4 Screenshot of Camille Utterback and Romy Archituv, *Text Rain*, 1999

Clause (2) acknowledges the idea that users generate displays by taking advantage of computational processes rather than knowledge. Clause (3) brings out that the activities of the user are done for the attention of an art-appreciative audience. Such an audience appreciates the work partly by attending to how users explore works by generating displays of them. Quite often the roles of audience and user are played by the same person, who attends to the work partly by attending to herself.

Acute observers of the new art form acknowledge the point. Bolter and Gromala beautifully describe Camille Utterback's *Text Rain* as incorporating its users into its displays (fig. 5.4). A large screen represents letters of the alphabet falling like rain. As the user approaches, her silhouette is captured and projected onto the screen, and the falling letters run off her projected image – unless they're redirected, channeled, or caught in a cupped hand. Bolter and Gromala observe that "the visitor immediately discovers [that] she herself becomes the show." It's "as much an expression of its viewers as of its creators ... [it] is about the process of its own making."[23]

More than a decade ago, David Rokeby saw the potential of this feature of computer art, comparing computer art works to "portraits, reflecting back aspects of the interactors." For this reason, they afford self-knowledge: "to the degree that the technology transforms our image in the act of self-reflection it provides us with a sense of the relation between this self and the experienced world."[24]

This journey through the ontology of computer art and the theory of the user sprang from a challenge laid down at the end of chapter 3 – to show that computer art, as defined by CAF, is indeed an appreciative art kind. We appreciate works of computer art primarily by generating displays of them, understanding that these displays vary a great deal, and that the work itself is to be appreciated through this variety. We also understand that our own actions generate these displays, so that we ourselves become objects of attention. Needless to say, we rarely put any of this explicitly; we may be stumped if asked to define a computational process or a user. That's neither here nor there, for our understanding is implicit in the way we engage with works like *Project X*, *Telegarden*, *Golden Calf*, *Kodama*, and *Boundary Functions*. We normally do appreciate works like these by comparison with each other, for their computer-based interactivity. Computer art is therefore an appreciative art kind.

6

COMPUTER ART POETICS

A sonnet written by a machine is better appreciated by another machine.

<div align="right">Alan Turing</div>

The computer art specialist Linda Candy wrote in 2002 that "a satisfactory critical framework for new forms in art technology has yet to be developed."[1] CAF provides such a framework if we appreciate works of computer art with an implicit understanding that they achieve interactivity through computational processing. It's time to tackle the value question (what's the value of computer art works?) and also to address the four critiques of computer art that were left unanswered at the end of chapter 2.

Creative value

The first of these was the argument from the creativity sink, which expresses the complaint that computers either impose artistic goals at odds with creativity or stifle creative expression by standardizing artistic activity. The upshot is that computer-based art lacks value. Here's the reasoning:

1 a work of art has value as art only to the extent that it expresses the creativity of its maker,

2 computer-based art works inhibit their makers' creativity,

3 so computer-based art works lack artistic value.

Remember that "computer-based works" covers both digital art and computer art, so one question is whether this argument applies specifically to computer art. Does computer art impose standards and goals that smother creativity? What does CAF have to say on the matter?

But first, it's worth thinking about the opening premise, that a work of art has value as art only to the extent that it expresses the creativity of its maker. This premise can be read in two ways, and both make the argument implausible. The crux is the meaning of "creativity." Needless to say, creativity is difficult to define, since it takes different forms in so many different areas of human endeavor.[2] That's not the real problem. Creativity implies novelty, but novelty depends on context, so any creative act is creative in one of two senses.[3] A personally creative act is one that's novel for the person who does it. A historically creative act is novel in the sense that nobody has done it before. Making my first drip painting is personally but not historically creative – Jackson Pollock gets the nod for historical creativity.

Which type of creativity does the argument from the creativity sink employ? If it employs personal creativity, then premise (2) is simply false. Using Google SketchUp I do something that I've never done before: I design a building. SketchUp supports psychological creativity, and the point of tools like SketchUp, Final Cut, and Garageband is that they narrow the gap between creativity and skill, reducing the amount of skill needed for creative drawing, film editing, and music-making. Alternatively, the argument speaks of historical creativity. In that case, it's possible to make a case for premise (2): some do say that standardization inhibits the kind of rule-breaking that's needed for artists to make things that are entirely new. However, is it true, as premise (1) now requires, that a work has value only in so far as it results from historical creativity? Surely many valuable works don't break entirely new ground. Pollock's first drip painting was entirely new, but he went on to make many more from the same mould. Requiring historical creativity sets the bar for artistic value too high.

Nevertheless, let's grant (1) and turn to premise (2), keeping in mind that it speaks of historical creativity. The premise states that computers inhibit artistic creativity. Two reasons support this: computers standardize art-making, and they impose goals on artists that stifle creativity.

To begin with, all media, including traditional media, standardize art-making processes. Pastels, the sonnet, and the diatonic scale each reduces the painter's, poet's, and composer's options, and each imposes a characteristic look or sound. So long as creativity can come from doing something fresh with limited options, standardization is no bar to creativity. On the contrary, the limitations of pastels, the sonnet, and the diatonic scale were creative opportunities for Degas, Shakespeare, and Mozart. Sometimes creativity thrives under constraints.

There's another problem with the point about standardization: it seems to target digital art rather than computer art as defined by CAF. It's true that some works of digital art have the Photoshop look or a canned sound. Some don't – look at the examples discussed in chapter 1, like Gehry's design for the Guggenheim Museum in Bilbao (fig. 1.6), and decide for yourself if they're historically creative. Be that as it may, there's little standardization in the look and feel of works like *Golden Calf*, *Telegarden*, *Project X*, *Boundary Functions*, or *Kodama*.

The second point meant to support premise (2) has the same flaw. The reasoning is that computer-based art aims at virtual reality effects, so the artist's goal is to copy the world without comment, but copying the world without comment smothers artistic creativity (especially of the historical type). The trouble is that nothing in CAF implies that computer artists must aim at virtual reality effects. Much computer art either shuns virtual reality entirely or toys with it in a way that undermines its pretensions – *Golden Calf*, for example. The point speaks to virtual reality art, not computer art as defined by CAF.

Rejecting these reasons for (2) isn't proof that it's false. It's an open question whether computer art is an effective outlet for creative expression. One way to answer the question is to see if making computer art fits a correct theory of creativity. Unfortunately, there's disagreement about what's required for creativity apart from novelty.[4] Resolving this disagreement may presuppose agreement on some paradigm examples of creativity, and making computer art may be a candidate. A quicker way is to see whether working with computers gave artists like Shaw, Goldberg, Lopes, Snibbe, and Yamakawa the same kind of opportunity to think outside the box as paint gave to Degas, iambic pentameter gave to Shakespeare, and the diatonic scale gave to Mozart.

The medium is the medium

According to the second critique, art's value is predicated on its supporting an experience of its medium, but computer-based art affords no such experience. Put formally:

1 a work (of our era) has value as art only to the extent that it invites an experience of its medium,

2 computer-based art works don't invite experience of medium,

3 so computer-based art works lack artistic value.

The second premise of this argument from the vanishing work is obviously the crux, and we'll want to know whether it applies to computer art in particular. Meanwhile, the first premise is worth a look too, for it contains a grain of truth and locating that truth helps us to understand computer art's medium.

One conception of medium is most famously associated with Clement Greenberg, who used the argument from the vanishing work to bludgeon art that he disapproved.[5] According to this conception, an artistic medium is a material stuff whose perceptible properties are the only appropriate focus of our attention on a work. The story is told that Greenberg sometimes positioned himself before a new painting in the dark, and then said "hit me" to have the lights turned on, thereby ensuring a pure visual experience of the painting, free of non-visual associations. In reaction to Greenberg, some artists in the 1960s and 1970s created "dematerialized" art objects where what seems important from an artistic perspective is something imperceptible. According to the artist's statement for his *Telepathic Piece*, Robert Barry states that "during the Exhibition I will try to communicate telepathically a work of art, the nature of which is a series of thoughts that are not applicable to language or image." Greenberg didn't like this sort of thing, and artists like Barry took their work to rebut his narrow conception of a medium.

The narrow conception of medium has a weaker grip on us than the more fundamental idea that when we appreciate a work of art, we attend to how its building blocks are used in order to pull off an effect or make a point. We don't just hear the harrowing message of "The Erlking"; we hear it as it's conveyed in Schubert's handling of the materials of music and lyric. As a rule, we attend to how X is worked to achieve Y, as we appreciate Y. This

suggests an instrumental conception of an artistic medium as a tool or technology whose use in the making or display of a work is relevant to appreciation (see chapter 1). On this broader conception, an artistic medium needn't be material or perceptible – even Barry's *Telepathic Piece* has a medium in this sense. And on this conception, a variant on (1) is plausible: the value of a work of art is determined partly by how its medium is used. That's almost a truism.[6]

Those who endorse the argument from the vanishing work typically think of medium in the narrow sense, and they typically think of computer-based art as digital art. For example, in discussing computer games, Espen Aarseth warns that "the computer is not a medium, but a flexible material technology that will accommodate many different media. Hence there is no 'computer medium.'"[7] Aarseth must understand a medium narrowly. The computer is a medium if we define medium broadly and the fact that some works are made with a flexible material technology is relevant to their appreciation.

Suppose we apply premise (2) specifically to computer art and substitute the narrow conception of medium with the broad, instrumental one. Now (2) quickly crumbles. CAF tells us that the instrumental medium of computer art is interactivity via computational processing. It's relevant to appreciation that some works achieve what they do by taking advantage of computer-based interactivity. Myron Krueger observes that computer art can "express the medium itself" by fostering user awareness of interaction: "the participant explores this universe [the work], initially triggering responses inadvertently, then gradually becoming more and more aware of causal relationships."[8] If one message of *Project X* is about storytelling as exploration and exploration as storytelling, then we get this message by experiencing it as conveyed through interaction.

Driving the point home is computer art that draws attention to interactivity by frustrating user interaction. According to Erkki Huhtamo, this kind of art "de-mythicises and de-automates prevailing discourses and applications of interactivity from the inside ... [it] undertakes a cultural critique of the nature of interactivity."[9] Lynn Hershman achieves this by making interactivity uncomfortable for users. In *Deep Contact*, a touch screen shows a woman, Marion, who addresses the user seductively, tapping on the screen, urging him to touch parts of the screen representing parts of her body (fig. 6.1). When he does, one of several sexual fantasy scenarios is displayed. Ken Feingold thematizes interactivity even more radically by utterly confounding the user's efforts to gauge the effects of her interactions. For example, his

Figure 6.1 Screenshot of Lynn Hershman, *Deep Contact*, 1989

Surprising Spiral is interactive, but it gives its user no sense of how her actions impact the work.

What these works do "in your face," other computer art works do with less confrontation. They sustain attention to interactivity as an artistic instrument.

Mind alert

The argument from mind numbing sometimes comes across as pretty shrill. For example, Paul Virilio fingers real-time computer processing as an accomplice in "narco-capitalism."[10] Nevertheless, the argument does express ideas worth taking seriously. Here's the argument as it was presented in chapter 1:

1 a work has value as art only to the extent that it abets active thought,

2 computer-based art works impede active thought,

3 so computer-based art works lack artistic value.

The force of this argument derives from a rather specific ideal of "active thought." Horkheimer and Adorno concede that works that stunt cognition might still demand quickness of mind and acute powers of observation.[11] For all that, they lack a crucial ingredient of active thought. Do computer art works have this ingredient?

Two reasons to believe premise (2) are borrowed from other critiques of computer-based art. If computer-based art essentially involves virtual reality, then it copies reality as we know it and so can't challenge our entrenched thinking. The assumption is that active thought must challenge entrenched ideas of reality. It should now be obvious why this complaint doesn't target computer art: CAF doesn't equate computer art with virtual reality art. The second reason for (2) has the same flaw. Computer-based art impedes medium awareness, but active thought requires attention to the medium. The reply is that if CAF is correct then the medium of computer art is computational processes that provide for interactivity, and we can and do attend to this medium.

A far more powerful argument for (2) does fit computer art as defined by CAF. Active thought requires distance, a condition affording focussed yet leisurely attention. When it comes to art, distance is needed to achieve an overall view of a work to understand how it's put together and how it works, and to arrive at a critical evaluation.[12] Now the claim is that computer art works, precisely because they're interactive, shrink distance. Automated display generation relieves the user of the performer's interpretive burden. Not having to think through the making of each display as Yo-Yo Ma has to think through his performances, the user is reduced to clicking a mouse while the computer does the work.

The analogy between computer art works and games is particularly damaging. Huhtamo observes that in playing video games, "the player gets 'glued to' a game, trying repeatedly to master more of its levels. The exchanges between the player and the game become, in a way, 'automated.'"[13] The point isn't that video games are completely mindless. That's patently false, as any player knows.[14] The point is rather that the games operate in real time, demanding lightning-quick responses that leave no time for reflection. The player is a reactor and hence in a way an extension of the machine: the machine operates as the player desires only as long as he uses his mind as the machine circumscribes. If interacting with computer art is like this, then Turing's line about machines appreciating machine art takes on new meaning.

One reply to this argument for (2) denies the analogy between video games and computer art and suggests that interacting with computer art works leaves time for critical contemplation. But another reply is more interesting because it accepts the game analogy and also because it directly exploits the lessons of the last two chapters.

Think of what it takes to appreciate a computer art work in its own right – not just one of its displays. The work has displays which are products of user interactions, but there's more to appreciating the work than interacting with it over and over. Since the work is the item which has many displays, appreciating it for what it is means thinking of it as holding possibilities that are realized through its displays. *Boundary Functions* is what goes this way if you do X and that way if you do Y. You can appreciate its going this way or that way – then you appreciate each display. You appreciate *Boundary Functions* itself when you appreciate the item that can go this way or that way depending on whether you do X or Y. *Project X* is a tangled web of story threads, and you can appreciate each thread in its own right, but you appreciate *Project X* itself when you gather up those threads to trace the story told by the telling of the individual stories. Returning to the game analogy, you may appreciate a playing of snooker, but you appreciate the game of snooker itself when you appreciate the possible playings that it has.

The lesson isn't simply that it takes great cognitive effort to appreciate a computer art work. Those who follow Horkheimer and Adorno already grant that. The mental sweat required to "beat" a video game diminishes distance, so sheer cognitive effort is no guarantee of distance.

Distance comes when we appreciate a work through repetition interspersed with reflecting on the significance of the differences between interactions. The metaphor of distance perfectly fits the process of appreciating computer art. The art work is hidden, the user's interactions are exploratory, and successive interactions bring the work closer into view. The situation is almost paradoxical. Getting entirely caught up in the interaction does nothing to undermine the fact that appreciating the work itself involves distance.

Confrontational works like *Deeper Contact* and *Surprising Spiral* secure distance by building it into the experience of each interaction. But this isn't the only way to inject distance into experiences of computer art. Distance is a feature of appreciating any computer art work as such. If that's right, then the second premise of the argument from mind numbing is false and the argument fails.

User agents

What Umberto Eco calls "open works" afford "acts of conscious freedom" on the part of the user.[15] Not everyone agrees. Some charge that computer art insidiously substitutes an illusion of control for actual control. This charge plays into the argument from mind control:

1 a work has value as art only to the extent that it abets free thought,

2 computer-based art works impede free thought,

3 so computer-based art works lack artistic value.

This argument carries most weight when it acknowledges and exploits the interactivity of computer art.

To get a grip on premise (2), recall the words of Manovich quoted in chapter 2:

> Mental processes of reflection, problem solving, memory and association are externalized, equated with following a link, moving to a new image, choosing a new scene or a text ... Now, with interactive media, instead of looking at a painting and mentally following our own private associations to other images, memories, ideas, we are asked to click on the image on the screen in order to go to another image on the screen, and so on. Thus we are asked to follow pre-programmed, objectively existing associations ... we are asked to mistake the structure of somebody else's mind for our own.[16]

David Rokeby offers another take on the idea. He writes that,

> interactive technologies ... reflect our desire to feel engaged. We feel increasingly insignificant, and so we desire the affirmation of being reflected; we are tired of the increasing burden of consciousness, and so we are willing to exchange it for this sense of affirmation. In this trade, the interface becomes the organ of conscience, the mechanism of interpretation, the site of responsibility.[17]

Interaction externalizes action and the responsibility that comes with it. The machine acts for us while giving us the impression that we act for ourselves.

These allegations contradict the discussion in chapters 3 and 5 of audience activities. Sometimes computer art's boosters claim that it transforms the passive spectators of traditional art into active spectators. This is partly right, since the user role does go beyond the role of the traditional art audience (chapter 5). However, the traditional art audience is hardly passive. Engaging with art calls for searching attention, adept handling of background knowledge, and productive interpretation. These activities epitomize "thinking for yourself," which good art demands. According to the argument from mind control, computer art's boosters get things exactly backwards. Traditional art demands active spectatorship, whereas computer art automates the user's engagement with a work. Searching attention, adept handling of background knowledge, and productive interpretation are replaced with clicking a mouse, hopping around a space, twitching an arm. These trivial actions call up canned interpretations from a menu of options prefigured by the artist. Users who feel that they're responsible for their interactions with the work actually labor under an illusion.

The reply to this argument draws upon everything we've learned so far: the argument gets wrong the nature of the activities that go into being a computer art user, and it gets this wrong because it misunderstands the ontology of computer art. The user generates displays of a work. She also attends to her generating a display of the work as part of trying to appreciate both the display and the work itself. The display and the work are twofold objects of appreciative attention: the user appreciates the display as one display among other possible displays, and she also appreciates the work as the item that has these possible displays. The more she interacts, the richer her sense of the work and its possibilities. Thus, as long as she's trying to get a sense of the work, her interactions will be guided: she'll act in ways that generate new displays that bring out the work.

The argument from mind control rests on several specific misconceptions. First, the fact that a range of displays is "canned" and "prefigured by the artist" does no more to control the user's explorations towards the work than does traditional art. A painting has only a single, unchanging display, yet nobody complains that it's "canned" and "prefigured by the artist." What really matters is whether users are free to work out the significance of the displays they encounter as displays of a work. That goes as much for *The Ambassadors* as *Telegarden*.

A second point explains the first. A display of a work isn't an interpretation of a work. It's the starting point of an interpretation. You generate a display of *Project X* – a story. Then you do another. That's not the end of your

job as a user. Your next task is to understand the significance of these stories individually and as displays of the one work. Automating displays doesn't take over the user's interpretive burden, but rather initiates it. The mistake is to suppose that generating displays through automation can replace interpretation. That's like supposing that Yo-Yo Ma's performing a Bach cello suite relieves the listener from understanding and appreciating the suite.

Finally, with freedom comes responsibility, and it's a mistake to view users as handing over responsibility to the machine. As long as their activities are directed at appreciating the work, they're governed by a norm. They should try to appreciate the work by interacting smartly and boldly. Since appreciation involves interpretation, users must try to interact so as to yield interpretive payoffs. Responsible users aspire to this norm.

Computer art as mass art

Although these four critiques specifically target computer art, they're retrofitted from broader critiques of mass art. Perhaps they also fail as critiques of mass art; but even if they succeed against mass art, they may fail against computer art, unless computer art has the very same vulnerabilities as mass art. So, does computer art share the vulnerabilities of other kinds of mass art? The place to start is with the conception of mass art that's implicit in the critiques of it.

In his 1998 book, *A Philosophy of Mass Art*, Noël Carroll presents a well worked-out account of mass art that articulates how it's viewed by critics and fans alike. At the core of Carroll's account is a succinct theory, here rephrased in the terminology of this book:

> an item is a mass art work if and only if (1) the item is a work with multiple displays, (2) that's produced and distributed by a mass technology, and (3) that's designed to be accessible virtually on first contact to a large number of relatively untutored audiences.[18]

The first clause needs no further explanation (see chapter 4). The action centers on (2) and (3).

Understanding (2) means seeing how it connects to (1). Carroll writes that,

> mass art is art that is produced and distributed by a mass delivery system, the first major one of which to emerge in the West was printing, which was

later followed in rapid succession by photography, sound recording, film, radio, and TV, and which undoubtedly will be augmented by laser technology, holography, HDTV, computer technology, and who knows what.[19]

These technologies stand apart from other art technologies like paint and canvas, bricks and mortar, and the theatrical stage. In particular, they can *simultaneously* deliver displays of a work to *multiple* reception sites. For example, viewers all over the United States simultaneously watch displays of *American Idol*, each on their own TV set, all at the same time.

Clause (3) rests on the shoulders of clause (2): mass art is "popular" or "low brow" art because it takes advantage of mass communications technology. Addressing a wide audience means addressing it in a language it can understand. Since displays of a mass art works are broadcast to multiple sites simultaneously, these works reach a wide audience, and they must be acceptable to a wide audience. So they go in for standardization, they avoid cognitive challenges, and they consequently serve as powerful tools to exploit their audiences. For most commentators, mass art is no good: mass art technologies dumb art down. Mass art is to art as doughnuts are to soufflé.

So much for mass art. Is computer art a kind of mass art? The answer is technically no. Non-technically? Yes and no.

Technically no because not all computer art works are broadcast to multiple reception sites. *Boundary Functions* is located in one place at a time. Copies could be made, but although these copies would be displayed at multiple sites, they're not delivered to those sites by a mass technology. The situation is more like casting two bronze *Thinkers* for different museums than like broadcast TV. The same goes for *Golden Calf*, *Kodama*, and *Wooden Mirror*. So it turns out that only some computer art exploits mass communications – works like *Project X* and *Telegarden*. This should be no surprise. The conception of a computer as designed for computational processing doesn't imply that computers are broadcasting devices. Computer networks have been around for decades, but to this day most computers aren't networked.

For those who find the technical answer unsatisfying, the next answer is yes and no. Yes because displays of computer art works are generated for multiple users through machine technology. However, the answer is also no. Critics of mass art clearly have in mind that mass technologies deliver pretty much identical displays to multiple sites simultaneously. Displays must be acceptable to a large audience only because they're very similar. That's true of all mass art before 1970: printing, photography, sound recording, film,

radio, and TV. Perhaps Carroll's theory of a mass production and delivery technology should be tweaked to say that such a technology *simultaneously* delivers multiple *very similar* displays of a work to *multiple* reception sites. If that's right, then displays of computer art aren't generated by a mass production and delivery technology. Each display is quite different from other displays. When you and I watch *American Idol*, we hear the same words issue from Simon Cowell's mouth. When we interact with *Kodama*, we hear quite different things.

We hear different things because we interact with it differently. The display that's generated depends on the action of the user. In principle, then, the display is tailored to address that user specifically. Remember that the hostile criticisms of mass art take exception to the drive to address the largest possible mass audience – an audience that's assumed to be unsophisticated. However, computer art works gather input from their users and only keep them engaged so long as their outputs are stimulating. They strive to reach each user in a way that works best for him or her. Snibbe details how different kinds of users approach *Boundary Functions*:

> Kids immediately understand the work the same way they understand jumping into a swimming pool – effortless joyful fun. Adults start this way, in their gut, and then the piece bubbles up to their mind – first thinking about the social and spatial effects, then more and more about the philosophical implications. For example, with *Boundary Functions*, the first reaction of everyone is to step on the lines that are drawn between themselves and the other people on the floor. These slip away, of course, and that adds energy to the space, creating a social stirring. Then adults start to contemplate the meaning. What's inside those lines? My personal space. But it's only defined by others and changes without my control. What a funny name for something that doesn't even exist without my relationship to others – my "personal" space is really purely defined by an intertwined social relationship to others.[20]

Computer art works can scale to different cognitive abilities and styles.

Although one might stop here and conclude that computer art isn't mass art, there's another conclusion to consider. What if we start with the conviction that computing is in fact a technology of mass production and mass communication that's continuous with print, radio, and TV. In that case, Carroll's original theory of a mass production and delivery technology is correct: this technology needn't deliver similar displays to multiple sites.

So computer art is mass art after all. Indeed, it's the next big development of mass art. If that's right, then it follows that computer art is mass art that refutes the hostile criticisms, by showing that they focus on a feature – having similar displays – that's not essential to mass art. Mass computer art works like *Project X* prove that the critics of mass art just aren't keeping up with the times.

Computer art criticism

Some computer art is successful and some isn't. The artist Brian Reffin-Smith confides that "ninety-nine percent of computer-based art is complete crap. But then ninety-nine percent of almost anything (and certainly other art forms) is complete crap."[21] Even a view as cranky as this implies that computer art works vary in value. In the quotation that opens this chapter, Linda Candy calls for a critical framework to represent this variation. The prospects for developing such a framework depend on our ambitions, and modesty recommends itself.

In its more ambitious mood, a framework for computer art criticism is made up of a set of principles that identify the features found in a high quality product. Principles like these are explicit in the four critiques of computer art. Quality art invites medium awareness, it expresses artistic creativity, and it abets active or free thought. Each of these principles sets a standard against which to measure the success or failure of art of any kind. Ideally, the principles making up a computer art criticism should fit the specific case of computer art. They should articulate what good can come from computer-based interactivity.

Not surprisingly, the ambitious approach is attractive to some artists, who wish to pass on what they've learned from experience in the form of guidelines for best practice. For example, in reaction to what he takes to be the poor quality of Internet-based interactive works that rely on mouse clicks for input, Don Ritter lays down that "the experience of interactive art should be an aesthetically pleasing experience not only for the mind but also for the body."[22] Here are a few more examples.[23] In good computer art, the user can attribute features of the display to their own actions, the way the display goes is surprising, the work draws attention to human embodiment, it taps multimedia and appeals to multiple senses, it approaches verisimilitude, and it discloses features of its underlying technology.

As ambitious as they might be, critical principles don't have to be absolutes. Nobody seriously suggests, for example, that a computer art work

succeeds only if it engages the whole body and fails otherwise. Rather, the principles are "pro tanto." They state what features of works are merits – what features add to the value of a work – without implying that all and only valuable works have those merits. Compare the pro tanto principle that a sense of humor is a merit in a teacher. A sense of humor makes someone a better teacher, but it's a trait not absolutely required in good teachers, and it can fail to convert a poor teacher into a good one. Many excellent teachers have no sense of humor at all, and teachers who don't know their subject can't redeem themselves by telling jokes. The same goes for the principles listed above. The principle that engaging the whole body is a merit in computer art isn't toppled either by an example of a worthy work that engages just a finger or of a failed work that does engage the whole body. Many merits can outweigh some faults and many faults can outweigh a few merits.

Even so, ambition is risky. The trouble is that a feature that's a merit in one case might turn out to be a fault in another.[24] For example, it seems to be a merit of *Wooden Mirror* that it closely ties the system's response to human gesture, but the very same feature would be a fault in Feingold's *Surprising Spiral*. There's nothing special about this example. It's a merit of *Telegarden* that it encourages cooperation among users, but can you imagine a work where this would be a fault? If you can, then it's not correct to say that, in general, encouraging cooperation among users is a merit in computer art works. The problem isn't that works may have different merits – pro tanto principles require nothing as strong as that. The problem is that they label some features as merits when, in fact, they're sometimes faults. So a more modest framework for computer art criticism does without principles.

Anything with value has value in some way or other. A fine Misono knife is useful as an instrument for cutting: it's good *as a knife*. It's also good in other ways – opening paint cans, for example (so it's good as a paint can opener). By the same token, it's bad in some ways. You might try to use it as a ladle, but it won't be much good. So anything is more or less good or bad in different ways. Of course, some of these stand out. Knives that are good at cutting stand out because knives are designed to cut, not to open paint cans or ladle soup. It's natural to focus on the value of each item as an example of its kind, even if it also has value in other ways.

Now consider why an item is good or bad as an example of its kind. The Misono knife is good as a knife because it's exceptionally sharp and durable. It's good as a paint can opener because it's a flat surface. It's bad as a ladle for the same reason that it's good as a paint can opener. So the reason why the

knife is good as a knife is that it has certain features – being sharp and durable – and one of these features is part of what makes it a knife. What about the reason why the knife is bad as a ladle? Well, it has a feature – being flat – that's incompatible with a feature that makes a ladle a ladle – having a shape that holds liquid. The reason why the knife is good as a knife refers to features that define knives and the reason why it fails as a ladle refers to features that define ladles. In general, an item is good or bad as a K when some of the reasons why it's good or bad as a K refer to features that define Ks.

So a work succeeds or fails as a work of computer art if some of the reasons for its success or failure refer to features that define computer art – if they refer, in short, to computer-based interactivity. Recall Ritter's complaint that too many computer art works are tedious because they reduce user input to clicking a mouse. If he's right, then the reason why these works fail mentions a feature that defines computer art – affording user input. Next, a positive example. Suppose *Boundary Functions* is interesting: by drawing Voronoi diagrams, it suggests how one's personal space is carved out in relation to the personal spaces of others. Here again, one reason the work is interesting refers to the fact that its display reacts to user input.

Note that only *some* of the reasons must refer to computer-based interactivity. Other reasons may have nothing to do with this. Some of *Kodama's* effectiveness may spring from its rich palette of colors, and maybe *Golden Calf* works so well in part because it provocatively alludes to biblical texts and to the tension between iconism and aniconism in the West. One of the mistakes of mid-twentieth-century criticism (influenced by Greenberg) was to assume that the value of a work must be *wholly* grounded in features specific to its medium. Greenberg's doctrine is far too restrictive. A modest framework for computer art criticism is one where *some* critical reasons touch on the defining features of computer art, on computer-based interactivity.

Reasons may take the form of principles, but they needn't. The reason why *Boundary Functions* is interesting needn't imply any principle saying that works of computer art are interesting to the extent that they comment on personal space. Perhaps some works are uninteresting because they have this very same feature. Unlike principles, reasons can represent features as merits in some works and faults in others. One reason why *Wooden Mirror* works is that it closely ties the system's response to human gesture. Yet we would have reason to fault *Surprising Spiral* if it had the very same characteristic. Some reasons aren't principles.

A critical framework of reasons without principles leaves it an open question exactly why any given work of art is good, bad, or indifferent. Only

careful, case-by-case scrutiny can tell. This is why such a critical framework is less ambitious. The ambitious route generalizes from the success and failure of many individual works to a set of principles that can be stated and followed. The principles sum up what's effective and what isn't. Since reasons are case by case, they don't generalize, and they can't be stated as a list. The most this modest framework can say is that when we judge a work as computer art as such, we take account of its use of computer-based interactivity.

In sum, a critical framework can manage without principles even as it's tailored to fit computer art. If we judge computer art works as works that engage us as users who interact with them, then we judge them *as computer art*. And yet we cannot marshal our judgements into principles.

Answers to the specialization question (what defines computer art?) and the value question (what's its value?) turn out to be interrelated. The defining features of computer art don't condemn computer art, and they figure into a framework for judging computer art. And if we judge works of computer art by taking account of their use of computer-based interactivity, then computer art is an appreciative art kind.

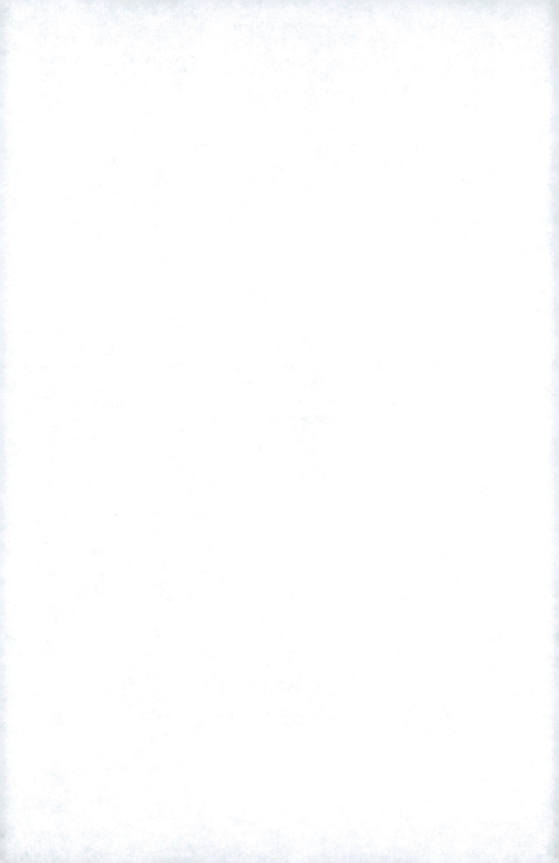

7

ATARI TO ART

If architecture is frozen music, then a video game is liquid architecture.

<div style="text-align: right">Steven Poole</div>

Attacks on the value of computer art often echo doubts about its status as genuine art. Yet CAF blithely assumes that at least some interactive, computer-based works are genuine art, and chapter 4 builds on this assumption by naming folks like Goldberg, Lopes, Shaw, Snibbe, and Yamakawa as playing the role of computer artist. But why assume that they really create works of art? Why, in other words, classify computer art as an appreciative *art* kind and not simply as an appreciative kind? After all, not everything we appreciate is art. To spice up the question, consider the analogy between computer art and games. Video games are run on computers, they're interactive, and they're interactive because they're run on computers, and yet many people, including avid gamers, find it quite comical to dignify such productions as *Pong* and *Grand Theft Auto* with the label of "art."

Video games: the challenge

The video game scholar Henry Jenkins captures what's funny about the idea of video games as art: we imagine "tuxedo-clad and jewel-bedecked patrons admiring the latest *Street Fighter*, middle-aged academics pontificating on the

impact of cubism on *Tetris*, bleeps and zaps disrupting our silent contemplation at the Guggenheim."[1] As in many jokes, the comic effect comes from bringing together incongruous images. On one side is the schoolchild hunched over a Game Boy, making Mario jump barrels; the awkward adolescent awake through the night, caught up in the *World of Warcraft*; or the commuter passing time playing *Super Monkey Ball* on her iPhone after a long day of mergers and acquisitions. Representing the other side are Kenneth Clark, *Gramophone* magazine, and readings at the Folger Shakespeare Library. Needless to say, both images are gross stereotypes. Art can be stodgy and elitist, but it's not always; and video games can be silly diversions, but they don't have to be. Taking seriously the analogy between computer art and video games requires a theory of each, plus a theory of art. We need to know what they are by nature, setting aside any accidental associations of frivolity and stuffiness. Enough has been said about computer art for now. That leaves video games and art. Let's start with video games.

Video games have been around since the 1950s, and were sold commercially beginning in the 1970s. Since then, they've been implemented on a great variety of platforms – arcade machines, dedicated home consoles like Game Boy and Wii, and mainframe or personal computers of all stripes. Some major genres include adaptations of traditional games, like *Pong*, text-based adventure games like Will Crowther's *Colossal Cave Adventure* (fig. 7.1), abstract puzzle games like Alexey Pajitnov's *Tetris* (fig. 7.2), first-person shooters like *Doom*, simulation games like Will Wright's *The Sims*, multiplayer strategy games like *World of Warcraft* ... the list goes on.[2]

Although games are traditionally trotted out in philosophy as the perfect example of a phenomenon that can't be defined, at least we can say that all games are interactive.[3] A work is interactive just in case (or to the degree that) it prescribes that the actions of its users help generate its display, where its display is a pattern or structure that we apprehend when we attend to it (chapter 3). Every game has a display. In checkers, it's the arrangement of tokens on a board; in poker, it's the set of cards in the hands of each player and the chips in the pot; in *Twister*, it's the placement of bodies on colored circles; in *The Sims*, it's images and text representing fictional events. Whatever form it takes, the display must change during the playing of the game and also from playing to playing, as a result of what its players do. This is fundamental. Imagine a set-up where nothing changed, or where nothing changed due to player action. This isn't just a very boring game; it's no game at all. Games are interactive in the sense that they have displays whose features are determined at least in part by their players.[4]

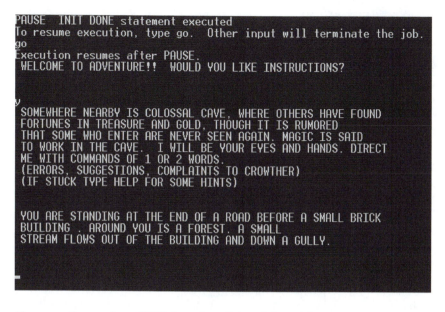

```
PAUSE  INIT DONE statement executed
To resume execution, type go.  Other input will terminate the job.
go
Execution resumes after PAUSE.
WELCOME TO ADVENTURE!!  WOULD YOU LIKE INSTRUCTIONS?

y
SOMEWHERE NEARBY IS COLOSSAL CAVE, WHERE OTHERS HAVE FOUND
FORTUNES IN TREASURE AND GOLD, THOUGH IT IS RUMORED
THAT SOME WHO ENTER ARE NEVER SEEN AGAIN. MAGIC IS SAID
TO WORK IN THE CAVE.  I WILL BE YOUR EYES AND HANDS. DIRECT
ME WITH COMMANDS OF 1 OR 2 WORDS.
(ERRORS, SUGGESTIONS, COMPLAINTS TO CROWTHER)
(IF STUCK TYPE HELP FOR SOME HINTS)

YOU ARE STANDING AT THE END OF A ROAD BEFORE A SMALL BRICK
BUILDING . AROUND YOU IS A FOREST. A SMALL
STREAM FLOWS OUT OF THE BUILDING AND DOWN A GULLY.
```

Figure 7.1 Screenshot of Will Crowther, *Colossal Cave Adventure*, 1975–7

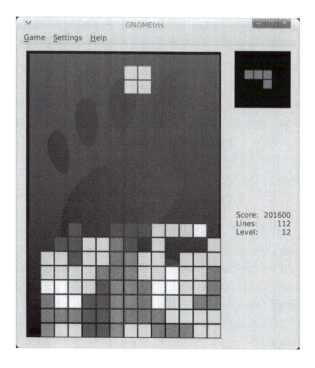

Figure 7.2 Screenshot of the Gnome version of Alexey Pajitnov, *Tetris*, 1985

Some game experts are reluctant to describe games as interactive, worrying that "interactivity" is a "runaway word."[5] Alexander Galloway prefers to call them an "action-based medium" because any work is interactive in the broad sense that "audiences always bring their own interpretations and receptions of the work."[6] In this broad sense, it's true that even Holbein's *Ambassadors* (fig. 3.2) is interactive (see chapter 3). However, not all art works are interactive in the more specific sense that their displays are generated by users. Interpreting *The Ambassadors* doesn't change its painted surface as moving a chess piece changes the configuration of the board. Moreover, Galloway's own conception of an "action-based medium" is no better than the broad, runaway idea of interaction. Music, painting, and poetry are all action-based media, for listening, looking, and reading are no less actions than moving one's body. Maybe games are "action-based" in the more specific sense that players' actions influence the flow of play. In that sense, action-based media are the same as interactive media.

If video games are games, then they're interactive, just like other games. What makes them video games is that they're interactive because they're run on computers. Here's why.

Every game has rules of some kind. Play without rules isn't game play. A rule in checkers empowers a player to "king" a piece by moving it to the "king row"; another rule restricts the movement of pieces to vacant squares. Together all the rules determine the possible displays that can be generated by playing the game. Given the current state of the display, the rules determine what subsequent display states are possible (chapter 4). In all games, the display changes; and in most games, the current state of the display is directly manipulated by players following the game's rules. My Queen's Pawn is at Queen 2. Following the rules of chess, I move it to Queen 4 and thereby change the display. I can easily change bits of my environment, but I play a game in the course of changing bits of my environment only because I'm following the game's rules.

In a video game, a computer automates some tasks that, in traditional games, are left to players. It modifies the display, based on user input, by implementing the rules of the game. So video games have displays with inputs and outputs and they have processors that run algorithms to implement rules, generating outputs from inputs. Computers are perfect for the job, since they're designed to run computational processes – processes that control transitions from input conditions to output conditions by following formal rules (chapter 3). Video games are interactive because they're run on computers.

These observations about games, interactivity, rules, and computers provide the building blocks for a theory of video games:

> an item is a video game just in case (1) it's a game, (2) it's interactive, (3) it's run on a computer, and (4) it's interactive because it's run on a computer.

Granted, this theory does paper over a big gap, since it leaves open the definition of games; but good definitions of games either state or imply that games are interactive. In the case of video games, circuits run computational processes to support player interaction.

Surprisingly, game-based theories of video games are controversial. Some experts view video games as games and hence as interactive, and they study the varieties and significance of user interactions.[7] At the same time, other experts stress the ties between video games and movies, literature, or performance.[8]

Without a doubt, stressing these ties does enrich our understanding of video games. For example, many video games feature moving images. Some build in purely cinematic sequences ("cut scenes"), during which players can't interact, but must sit back and watch. Many video games without cut scenes still take advantage of players' familiarity with the language and conventions of movies. First-person shooters like *Doom* use the point of view shot, and even a simple game like *Pac-Man* gets players to identify with its protagonist, leaping with joy when "they" eat a power pellet, howling with anger when "they" get taken down by Blinky the Ghost. Film scholars, who study point of view shots and character identification, can shed light on how these phenomena contribute to video games and experiences of playing them.

The trouble is that not all video games use cinematic devices, or narrative, or even representation. *Colossal Cave Adventure* has no moving images (fig 7.1). Video baseball is pretty short on narrative. *Tetris* represents nothing (fig. 7.2). Of course, counter examples are never decisive. Someone who defines video games as moving images may bite the bullet and insist that *Colossal Cave Adventure* isn't a video game. That's fine, but then we miss some interesting affinities between games like *Colossal Cave Adventure*, *Tetris*, *Myst*, and *Warcraft*.

More importantly, there's no need to bite the bullet, for nothing in the theory of video games as games, and hence as interactive, blocks the use of film studies to help understand those that have moving images, or the use of literary theory to help understand narrative games. We need only choose

between approaches if every video game belonged *exclusively* to the category of games. Obviously, most items in our world belong in many categories. An item can belong in the category of mangoes and also in the category of items in my cupboard, and *Myst* belongs in the category of games as well as the category of moving images. All video games are games, and can be studied as such, but some video games are also moving images and some are also narratives, and they can be studied as moving images and narratives. In short, nobody should resist defining video games as games just because they're interested in the filmic or narrative elements in some video games.

As you've probably noticed, the above theory of video games closely resembles the theory of computer art summed up in CAF. Their final three clauses are identical. Like works of computer art, video games are interactive, they're run on computers, and they're interactive because they're run on computers. The only difference is that computer games are games and computer art is art. But why not add that video games are art? Back in 1984, during the early days, the game designer Chris Crawford proclaimed that video games are art. If he's right (and this is the important part), then it turns out that video games are computer art.

What's art got to do with it?

The question has popped up time and again over the past century as new media have made bids for art status. While photography was first touted as an amazing technological novelty, its admirers soon argued that photographs rise to the level of art and belong alongside paintings and sculptures. A few decades later, the process was repeated with movies, whose backers championed an art of cinema. Presumably it matters whether photographs or movies are art. Why it matters should be apparent in a conception of the nature of art. The philosopher Richard Wollheim observes that,

> if we wonder whether assemblages, installations, earth-art, performance-art, conceptual art, video-art, will survive, not just as hobbies, not just as technology, but as art, we all know that there is nothing for it but to wait and see. But when we do, the big question is: What are we waiting for? What will there be to convince us, or convert us when it heaves into sight?[9]

An answer to Wollheim's big question is a theory of art.

Wollheim's own answer stresses that every work of art issues from "some recognizable and repeatable process" – that is, a medium.[10] As we saw in

the previous chapter, it's a common mistake to equate a medium with some material stuff out of which works are made, like papier mâché or marble. Media are, more broadly, tools for making – and some examples are the English language and the diatonic scale (and papier mâché and marble too). Of course, not everything made with the English language, the diatonic scale, or papier mâché is art – stop signs, door chimes, and dime store Halloween masks, for instance. So being convinced that some products of the video medium are art doesn't mean accepting everything on YouTube as art, and being converted to earth art, as represented by exemplars like Robert Smithson's *Spiral Jetty*, doesn't make everyone driving a backhoe into an artist. The job of a theory of art is to state the features which distinguish some works in a medium as works of art.

What are these features? Here's a list of candidates compiled by Berys Gaut:

> (1) possessing positive aesthetic properties, such as being beautiful, graceful, or elegant (properties which ground a capacity to give sensuous pleasure); (2) being expressive of emotion; (3) being intellectually challenging (i.e. questioning received views and modes of thought); (4) being formally complex and coherent; (5) having the capacity to convey complex meanings; (6) exhibiting an individual point of view; (7) being an exercise of creative imagination (being original); (8) being an artifact or performance which is the product of a high degree of skill; (9) belonging to an established artistic form (music, painting, film, etc.); and (10) being the product of an intention to make a work of art.[11]

The list is comprehensive and certainly covers the feature typically mentioned in contemporary theories of art, but not every theory of art favors every feature on the list.

Some theories of art aim for unity. They state that one feature on Gaut's list (or a combination of two or three of them) is found in every work of art, and only in works of art. An example is Monroe Beardsley's aesthetic theory, which defines works of art as all those artifacts, and only those artifacts, that are designed to elicit an "experience with marked aesthetic character."[12] This privileges (1) as the defining feature of art. Expression theories likewise privilege (2) and formalist theories privilege (4).[13]

Unified theories face a dilemma. It seems that no feature or combination of features pulled from Gaut's list is both common to every work of art and is also found exclusively among works of art. Take Beardsley's theory.

Some artists sought to create works that inhibit experiences with a "marked aesthetic character." Perhaps John Cage succeeded with 4'33", a work for piano, which consists of about four and a half minutes of a pianist not playing the piano. Attending a performance of this work isn't designed to elicit any experience of beauty, gracefulness, elegance, or any other feature that evokes sensuous pleasure. Beardsley also says that only works of art are designed to induce an experience with a marked aesthetic character. In that case, some automobiles, housewares, articles of clothing, and sporting events are works of art, because they're designed to afford experiences of beauty, elegance, gracefulness, and the like. Now, these examples don't prove that Beardsley's theory is wrong. Whereas one option is to reject the theory and dissociate art from the aesthetic, another option is to insist that 4'33" isn't art and that the Audi TT, a Martha Stewart coffee cup, a Chanel dress, and springboard diving are art. Neither option seems terribly convincing: hence the dilemma.

Cluster theories seek to avoid this dilemma. They group features from Gaut's list into certain clusters, so that any work of art (and only works of art) have all the features in one of these art clusters. Maybe one art cluster is made up of (2) and (10), and Cage's 4'33" is art because it was made as art and it challenges received views about what's supposed to happen in piano music. And maybe the Audi TT and springboard diving aren't art because they don't have all of the features of any of the right clusters. Thus springboard diving fits (1), (4), (6), (7), and (8), but perhaps these don't make up an art cluster. Since not every grouping of features from Gaut's list makes up an art cluster, it's up to us to discover which clusters are the right ones. Looking at tricky cases like 4'33" and springboard diving can reveal how to assemble the right art clusters.

Unified theories and cluster theories recognize art-making features like those found on Gaut's list. Institutional theories dispense with them altogether. What's unsatisfactory about institutional theories brings out the importance of the features on Gaut's list.

According to a classic version of an institutional theory, what makes something a work of art is that it's an artifact that's had art status conferred upon it by a member of the art world.[14] Everyone knows that art works are socially embedded items. They're displayed in museums, concert halls, and theaters; they're sold by artists to publishers and collectors and thus enter regulated art markets; and they're subject to taste trends and fashions on the part of their audience. However, institutional theories go beyond acknowledging these obvious facts to claim that they define art. They claim, putting

it crudely, that what makes something art is nothing more than the fact that it's displayed, traded, or otherwise treated as art.

Like any theory, a theory of art should be informative, and institutional theories of art aren't informative. Why do some works have art status conferred upon them? Does the art world have any reason to confer art status on 4'33" and not springboard diving? If it has a reason, then why doesn't that reason tell us what makes the former art (and not the latter)? For example, maybe 4'33" questions received views and modes of thought, unlike springboard diving. In that case, why not admit that's what makes it a work of art? And consider the alternative, that the art world has no reason to confer art status. In that case, why should it matter what gets art status? Suppose that an item has all the features on Gaut's list and yet gets shunned by the art world. We have every reason to treat it just like a similar item with official art status.

Why computer art is art

Let's apply this first to computer art. Although philosophers disagree about the nature of art, the disagreements don't jeopardize the case in favor of art status for computer art – and making that case will set us up to consider video games as candidates for art status.

Speaking of his early work, Snibbe says, "I did not realize [my] experiments were 'art' until ... several curators invited me to art shows, particularly Ars Electronica, which changed the course of my career, now that I knew my hobby had an audience and a name."[15] Abundant social signals indicate that we regard works like Snibbe's as art. They're exhibited at blue-ribbon institutions like the Museum of Modern Art and also at venues devoted to electronic art, such as Ars Electronica, which takes place every summer in Linz, Austria. These exhibitions are reviewed in art magazines, and individual works are analyzed in detail in art magazines and books. Art agencies and foundations fund the making and display of computer art, and art schools now train students to be computer artists. Clearly, the computer art world is well established.

Yet Snibbe doesn't rely on the judgement of the curators alone. He goes on to explain why their judgement is justified: "interactive works ... portray the entire spectrum of artistic inquiry ... sublime, beauty, obsession, fashion, politics, anger, violence, self-observation, portrait, narrative, poetry, abstraction, etc."[16] Following Snibbe, we can ask how computer art fares on Gaut's list.

It's not enough to show that works like Snibbe's have some features from Gaut's list. Suppose that *Kodama* only deserves art status because of its beautiful graphics. A skeptic may reply: that only proves it's a work of visual art. Sure, some works of digital art are also works of visual art, but none are computer art! The question is whether some works made by computer have features on Gaut's list specifically because of their computer-based interactivity.

Some items on Gaut's list are not relevant. Take (9) – belonging to an established art form. If computer art isn't an established art form, then some works of computer art (the ones that aren't also stories, images, or structured sounds) don't belong to an established art form. No matter, for we can't require every work of art to belong to an established art form. The first movies didn't belong to an established art form, and neither did the cave paintings made thirty thousand years ago at Chauvet. So (9) isn't strictly necessary for art status.

On the flip side, works in a new medium are very likely to be original and to result from creativity. The argument from the creativity sink says that computer art is an exception that saps artistic creativity, even as it demands a high degree of skill. The previous chapter tries to bring out why that argument is wrong.

The argument from mind numbing suggests that computer art can't be intellectually challenging, can't convey complex meanings, and can't convey an individual perspective. As we saw, the argument assumes that being caught up in making a particular display of a work erases the distance needed for serious thought. Whether or not this is true, it entirely misses the fact that we appreciate computer art works through their different displays, just as jazz fans appreciate jazz standards by listening to different versions of them. This delivers distance. *Golden Calf* challenges received views about sculpture, suggests complex meanings about idolatry, and conveys Shaw's perspective on these matters. It does this because it's interactive and requires its user to work with it to construct the virtual Golden Calf.

The expression of emotion? *Kodama* is threatening. Not because the voices make statements promising harm, but because they eavesdrop on you, pick up what you say, and whisper it back to you. Its interactivity makes it creepily threatening.

Computer-based interactivity is also responsible for the positive aesthetic properties of some works, including their formal complexity and coherence. The way the tessellations of *Boundary Functions* morph smoothly one into

another as users move about the platform is graceful and even elegant, and the pattern has a kind of mathematical complexity and coherence that rivals Mondrian's grids.

Of course, doubters are free to grant all this and yet insist that no interactive, computer-based works cross the line into art. But then it's hard to see what difference it makes to them what counts as art. After all, they grant that the works have the features on Gaut's list, and these are the features that matter.

Video game art?

It's hard to sympathize with those who might deny art status to these works by Goldberg, Yamakawa, and Snibbe. It's far easier to deny that video games like Tetris and Grand Theft Auto also count as art. But, like works of computer art, video games are interactive because they're run on computers. So if they're art, then they're computer art. Are they art?

It's best to focus on "off the rack" video games. Adaptations of games by acknowledged artists are a bit of a cheat. One such adaptation is machinima, where artists create animated movies by co-opting video games (see chapter 1). Likewise, mods or patches change the software running a video game in order to produce a new effect.[17] While some mods simply customize games for players (e.g. the popular Nude Raider Patch for Tomb Raider), others undermine the premises of a game or of video game culture, as in Joan Leandre's retroyou RC series, which deconstructs a car racing game. Thomson and Craighead's Triggerhappy reverse engineers Space Invaders, replacing the invaders with a quotation from Michel Foucault's "What Is an Author?" which the player must shoot out of the sky (fig. 7.3). These are easy cases of art.

Setting aside adaptations, off the rack video games show signs of art status. They're displayed in institutions like the American Museum of the Moving Image.[18] Collectors preserve and trade vintage game equipment and original source code. Exceptionally creative designers like Shigeru Miyamoto, who made Mario, and Will Wright, creator of The Sims, are treated as auteurs who leave an individual impression on their oeuvres.[19] Some win awards from prestigious outfits like the British Academy of Film and Television Arts, and their work is discussed in scholarly journals. They even get discussed in books like this one.

Is this conferral of art status deserved? An answer can draw parallels between video games and more traditional art forms. Indeed, those who view video games not as games but rather as moving images or narratives

The coming into being of the notion of "author" constitutes the privileged moment of individualisation in the history of ideas, knowledge, literature, philosophy, Even today, when we reconstruct of a such categories seem relatively weak.

Figure 7.3 Screenshot of Thomson and Craighead, *Triggerhappy*, 1998

may be trying to justify their status as art. Some ask, "if [video] games are art, then what kind of art are they, and what kind of already existing and well-established art forms might they resemble?"[20] Putting the question this way assumes that new art inevitably resembles traditional art.

Consider the features on Gaut's list. Video games present narratives and moving images. By doing so, they evoke the same kinds of emotional responses as we see in the classic fiction and film genres.[21] For example, Monolith's *F.E.A.R.* is designed to evoke fear tinged with disgust, centering on a "monster" in the guise of a little girl with paranormal powers: it fits a textbook definition of horror.[22] Video games also explore themes and carry messages. Violence is an instructive example, for while their violence is often a source of complaint, Judge Richard Posner quite rightly points out (in a ruling striking down a municipal restriction on video games) that "classic literature and art ... is saturated with graphic scenes of violence."[23] Video games can also carry messages about their themes. Players of Newsgaming's *September 12* must hunt down terrorists with weapons that kill innocent bystanders.[24]

Although parallels between video games and traditional arts are important and deserve attention, they don't in the end help the case for an art of video games. Suppose that *Myst* is a work of art because of its lush and

Figure 7.4 Screenshot of Ubisoft, *Myst*, 1991

polished graphics (fig. 7.4). In that case, what makes it art isn't what makes it a game, since its graphics don't make it a game. It's not a work of game art; it's a work of graphic art. Picking up on this, some commentators distinguish what they call the "art" in a video game from "gameplay." Nolan Bushnell, Atari's founder, states that "good gameplay can exist without art. Gameplay is necessary, whereas art is not."[25] Espen Aarseth, a game expert, agrees that "games ... share qualities with performance arts, material arts ... and the verbal arts ... But, fundamentally, they are games. The artistic elements are merely support for the gameplay."[26] Here Bushnell and Aarseth assume that art is performances, images, or text, so games are not art.

Maybe this assumption is wrong and video games are game art. Maybe they're art precisely because of how they work as games. Since gameplay implies interaction, maybe they're art because of their interactivity. The right parallel isn't to stories or movies but to computer art.

Game designers can certainly exercise a high degree of skill and creative

imagination in generating graphics and telling stories and also in implementing the interactive elements of games. Chris Crawford puts this clearly: "in a game, the designer creates not the experience itself but the conditions and rules under which the audience will create its own individualized experience."[27] The interactive gameplay that results can be enthralling. Not only can it arouse emotion, but its emotional power is one of its strengths and a major factor in its appeal. Beauty and formal complexity and coherence are also factors alongside beauty. Steven Poole writes that,

> a beautifully designed video game involves wonder as the fine arts do, only in a uniquely kinetic way. Because the video game must move, it cannot offer the lapidary balance of composition that we value in painting; on the other hand, because it can move, it is a way to experience architecture, and more than that to create it, in a way which photographs or drawings can never compete. If architecture is frozen music, then a video game is liquid architecture.[28]

The point isn't that we should elevate video games to the level of architecture or music, but that each of these art forms realizes positive aesthetic properties in its own way.

Meaning through play

That leaves challenging the intellect, conveying complex meanings, and expressing an individual point of view; and this is where eyebrows are wont to twitch into a frown. Video games are widely equated with stupefaction. True, massive amounts of brain power go into playing some games, and games that don't push the boundaries of mental performance are mostly no fun to play. Nevertheless, the concern is that video games don't leverage interactive gameplay to challenge received ideas and convey complex meanings. When they work well, their players are too absorbed in the gameplay to have room to step back and work out complex meanings or question received ideas. Concerns about lack of distance and mind numbing appear to fit video games to a T.

Before addressing these concerns, it's worth pausing to see if challenging the intellect, conveying complex meanings, and expressing an individual viewpoint are needed for art status. Having these features normally adds to an art work's value, but it's another thing entirely to say that no work deserves art status without them. Counterexamples abound. Mozart's "Eine

kleine Nachtmusik" challenges no received views or modes of thinking, conveys no complex meanings, and expresses no individual perspective on the world, yet it's a work of art. Maybe charming diversions are fine for the eighteenth century, but not more recent art? As a matter of fact, it's a dogma in some circles that contemporary art must take an "oppositional" stance and critique culture, politics, or art itself. Again counterexamples abound. Despite the fraught associations of its location, there's no hint of critique in Santiago Calatrava's design for the PATH at the site of the World Trade Center in New York. Does that prove it's not a work of art? Suppose advocates of contemporary art's essential criticality bite the bullet and deny it status as art. That will make little difference in our response, which is firmly rooted in its having other features from Gaut's list, features that it shares with much art of the past. Put it this way: if video games belong with Mozart's chamber music and Calatrava's PATH rather than Cage's 4'33" or Daniel Libeskind's Jewish Museum in Berlin, well, that's still worthy company.

Keeping in mind that art doesn't have to challenge the intellect, convey complex meanings, or express an individual viewpoint, why think that video games can do none of these? The media critic Andrew Darley sums up the concerns about lack of distance. Video games offer only "surface play" and "direct sensorial stimulation," and so leave little room "for reading or meaning-making in the traditional sense." As a result, they appeal to the "seeker after unbridled visual delight and corporeal excitation," who is "more of a sensualist than a 'reader' or interpreter." The culprit is interactive gameplay, which channels attention into having new experiences, so that top priority goes to making it to the next level of the game. "Computer games are machine-like: they solicit intense concentration from the player who is caught up in their mechanisms ... leaving little room for reflection other than an instrumental type of thinking that is more or less commensurate with their own workings."[29] Interactive gameplay gets in the way of challenges to received opinion and familiar modes of thought, complex meanings, and individual viewpoints.

The mistake in this critique is to view the player's experience as one of total absorption in video games' displays – in the here and now. It can be like this, but it doesn't have to be. Absorption in the current play of a game is consistent with reflection on the game itself over time. By attending to repeated displays and how they change as a result of their actions, players attend to the game as generating a range of possibilities. That opens up room for reflection on the game itself. Thus a game can express ideas through the range of possibilities it generates, and multiple playings afford the distance

needed to grasp these ideas. The source of the mistake is to assume that only texts and images are fit for interpretation. In fact, the range of play a game generates is another kind of object for interpretation.

Many video games aren't designed to take advantage of the opportunity to use gameplay as a platform to challenge received wisdom, transmit complex ideas, or express an individual vision. Even so, human beings have a strong drive to find meaning everywhere. For instance, in *Space Invaders*, the more "invaders" the player "kills," the faster they come, and every player is eventually overcome. It's hard to resist allegorizing this aspect of the *Space Invaders* algorithm.

Some games are designed to prompt serious reflection. Not just games targeted at a small educational or intellectually high brow market. The top-selling video game as of 2008 is *The Sims* by Will Wright. In 1991, Wright's house was destroyed in the Oakland Hills firestorm, and, compelled to furnish a new house from scratch, he asked himself "what's the least number of motives or needs that would justify all this crap in my house? There should be some reason for everything in my house. What's the reason?"[30] For an answer, Wright looked first to Christopher Alexander's *Pattern Language*, a compendium of architectural features that, according to Alexander, can be combined to produce satisfying living spaces. He also looked to Abraham Maslow's hierarchy of human needs for a classification of satisfactions.[31] These texts directly shaped the scoring system of *The Sims*, which connects environment to happiness. But although the game models these architectural and psychological theories, Wright didn't assume that they're correct. The question of the game's realism comes up over and over for players. When it does, they're thinking about its adequacy as a model of how environment (including the stuff in it) relates to satisfaction. They're thinking about this not in the abstract, but as experienced through playing the game.

Art disqualifiers

Nothing in principle – nothing in the theory of video games – prevents video games from having the features on Gaut's list, and some games have many, even all, of the features. So either these video games are works of art or, if we still withhold them that status, they're art in all but name only. But maybe this reasoning is faulty. What we look for in art depends in part on what has come up in the past as a candidate for art status. Until recently, nobody's seriously proposed that games might be art. Perhaps there's something about video games that disqualifies them as art?

One objection to the claim of video games to art status is that they're commercial products. The reasoning is that nothing is art if it's a commercial product, and video games are commercial products, so video games aren't works of art. This argument taps into a cherished ideal of art as free of commercial interests, but it's unsound. To begin with, not all video games are commercial products. Dramatic evidence of this is the thousands of freeware games people have created. More importantly, a great deal of traditional art, including some of the very best art, is commercial. This includes most contemporary prose literature, popular music, feature-length movies, and mainstream dance and theater. Come to think of it, it's not clear how a painter in SoHo making works for sale through dealers is any less engaged in commerce than Akira Kurosawa making movies for Toho Studios or Will Wright making games for Electronic Arts.

It's often said that video games are entertainment, hence not art. The reasoning is that nothing is a work of art if it's an entertainment, and video games are entertainments – they amuse, divert, bring pleasure. However, drawing a sharp line between art and entertainment comes with a hefty cost.[32] It implies that *A Midsummer Night's Dream*, performances by Django Reinhardt, many of the paintings of Paul Klee, Bernard Tschumi's Parc de la Villette in Paris, and most of the movies made by Steven Spielberg aren't art. Again, *Colossal Cave Adventure* and *The Sims* aren't in bad company.

In the press, video games are typically represented as dangers, especially to children. The worry is that they're addictive, they take up time that should go to learning, and they keep children glued to the screen, thereby causing obesity and other health problems. Each of these worries is justified to some extent (though sometimes exaggerated). Then, as one writer exclaims, tongue in cheek, "computer games are not art. Computer games are dangerous!"[33] However, that follows only if art works cannot be dangerous (especially to children). Is that true?

Ultimately objections like these fail for two reasons. First, nothing in the theory of video games seems to imply that they have the disqualifying feature (being commercial products, being entertaining). So some video games will squeak past the disqualification. Second, nothing on Gaut's list seems to be inconsistent with the presence of the disqualifying feature. For example, there's no reason why commercial products can't challenge received ideas and modes of thought, and there's no reason why entertainments can't have positive aesthetic qualities. The result is that attempts to disqualify video games from the art world risk tossing the baby out with the bath water.

In the end, there's nothing for it but to rethink whether there's any good reason to deny that at least some video games have what it takes to be art, or whether opposition is an irrational prejudice. Consider these words:

> where it prevails as a habit, it occasions in time the entire destruction of the powers of the mind: it is such an utter loss ... that it is not so much to be called pass-time as kill-time. It conveys no trustworthy information as to facts; it produces no improvement of the intellect, but fills the mind with a mawkish and morbid sensibility, which is directly hostile to the cultivation, invigoration, and enlargement of the nobler faculties of the understanding.[34]

Doesn't that sum up the case to disqualify video games from art status? Yet these words were spoken two centuries ago by Samuel Taylor Coleridge. His bogeyman? The hot new art craze of his day: novels.

ENVOI

A NEW LAOCOÖN

Does including video games in computer art weaken or strengthen the case for the thesis that computer art is a new art form? One might reason as follows. If there's a computer art form then it includes video games, but video games aren't art, so there's no computer art form. Rather, it's better to classify all the works we've looked at in the first six chapters as digital art, and it just turns out that some digital art works are interactive. That's one way to look at things. Here's another. There's reason to expect that we can learn something about computer art by recognizing video games as computer art. That might strengthen the case for the thesis that computer art is a new art form.

During the past century, our thinking about art has gone through several dramatic shifts. Counterbalancing the dominance of the avant-garde over some corners of the art world, we now acknowledge the value and importance of the popular arts.[1] The music of Palestrina, Wagner, and Pierre Boulez attracts a niche audience, but the total audience for music includes fans of James Brown, The Clash, and Arcade Fire. A cross-section of film runs from Ingmar Bergman and Jean-Luc Godard to Martin Scorsese, Steven Spielberg, and Judd Apatow. *Harry Potter* sits on the literature shelf alongside *Beowulf*. Of course, the productions of the avant-garde can differ enormously from those of the mainstream, but no defensible theory restricts art to the avant-garde.

Counting video games as computer art extends the audience for computer art far beyond one smallish corner of the larger art world. Computer art runs from *Colossal Cave Adventure* to *Project X*, and from *The Sims* to *Golden Calf*. Narrative exploration is fun and revealing for "low brow" as well as "high brow" audiences, and members of both kinds of audiences are interested in playing with and also thinking critically about simulation. Maybe a broadened and open-minded view of the new art form promises some useful insights.

For example, video games afford play, and some see playfulness as the defining quality of computer art.[2] This is something new in art. True, it's commonly said that all art invites playful interpretation. However, if interpretation is generating hypotheses about why a work has the features it has, so as to get something from it, then interpretation isn't the same as playing games (though playing games can involve bouts of interpretation too). The equation of interpretation with play is a metaphor. The same goes for Kendall Walton's proposal that all art involves games of make-believe like those we see in children's play.[3] This proposal isn't meant to say that looking at *The Ambassadors* or listening to "Summertime" is literally play. By contrast, computers make play, literal play, a resource of art, and works like *Boundary Functions* are clearly opportunities for play (even if they use their own playfulness to leverage quite serious messages).

The notion of flow, which characterizes an important feature of video games, also applies to computer art. Part of the holding power of a good video game is its challenging its players in a way that keeps pace with their ability (within a given range). This is possible because the game gathers information about its players, from their plays, and displays an output accordingly. In many games, this is formalized in the metaphor of levels which players attempt to "beat." Something similar goes for computer art works, which can be built to adjust their displays to the abilities, presuppositions, or mental horizons of their users. It might be useful to understand the success of some computer art by using the concept of flow.

Of course all good art holds the attention of its audience. Some traditional art does this only because its audience changes. Proust meant something different to me when I read him at forty than when I'd read him twenty years earlier. Some other kinds of traditional art holds its audience's attention for this reason and also because it has varying displays – we're interested in new performances of even (or especially!) the most familiar musical works. This still falls short of flow. Some works of computer art are different: they hold our attention because their displays change in coordination with changes

in us. Hence the possibility of flow, which explains the particular holding power of some video games and computer art works.

The overarching strategy of this book has been to work out how the technology of computing underwrites a new art form, which is a distinct appreciative art kind. Implementing this strategy meant saying something right off the bat about the nature of computing as computational processing. Computer art takes advantage of computational processing to achieve user interaction – to control changes to varying displays depending on what users do with them. Computer art is an appreciative art kind if users normally appreciate works like *Kodama* and *Telegarden* as belonging to a group of works that are also interactive in this way. Acknowledging its kinship to video games highlights what's special in our appreciation of computer art.

Astute readers may have noticed that arguing that computer art is an appreciative art kind falls short of proving it's an art form. All art forms are appreciative art kinds – so digital art isn't an art form because it's not an appreciative art kind (chapter 1). But not all appreciative art kinds are art forms. Some are subcategories of art forms (e.g. digital movies are an appreciative art kind within the cinematic art form). Other appreciative art kinds cut across different art forms, notably genres.[4] Horror comes in movies, comics, stories, and maybe even music (e.g. "The Erlking"). However, it's not plausible that computer art is a genre or a traditional other art form.

In the end, the label is hardly what matters. What matters is what we can learn about works like *Golden Calf*, *Telegarden*, *Project X*, and *Boundary Functions* – and what we can learn about our appreciation of them – by making a case for the proposition that computer art is a new art form.

NOTES

Preface

1 Noël Carroll, *A Philosophy of Mass Art* (Oxford: Oxford University Press, 1998).
2 G. H. R. Parkinson, "The Cybernetic Approach to Aesthetics," *Philosophy* 36 (1961), pp. 49–61.

1 The machine in the ghost

1 Mark Tribe and Reena Jana, *New Media Art*, ed. Uta Grosenick (Köln: Taschen, 2006), p. 6.
2 For example, Michael Rush, *New Media in Late 20th-century Art* (London and New York: Thames and Hudson, 1999).
3 Richard Wollheim, *Art and Its Objects*, 2nd edn (Cambridge: Cambridge University Press, 1980).
4 Virginia Heffernan, "Sepia No More," *New York Times Magazine* (April 27, 2008), pp. 18–19.
5 Jim Andrews, "Seattle Drift" (1997), http://www.vispo.com/animisms/SeattleDrift.html, accessed 8 May 2009.
6 See http://www.youtube.com/watch?v=30DsJ8eOmKA, accessed 8 May 2009.
7 William J. Mitchell, *The Reconfigured Eye: Visual Truth in the Post-photographic Era* (Cambridge: MIT Press, 1992).
8 "Dassault Systems and IBM Sponsor Frank Gehry, Architect, at the Solomon R. Guggenheim Museum in New York City," *Business Wire* (May 16, 2001).
9 David Cope, *Computer Models of Musical Creativity* (Cambridge: MIT Press, 2005). Hear samples at http://arts.ucsc.edu/faculty/cope/music.htm.

10 Harold Cohen, "The Further Exploits of AARON, Painter," *Stanford Humanities Review* 4 (1995), pp. 141–58
11 Andrew Stern, "Harold Cohen on Artist Programmers," Grand Text Auto (June 17, 2003), http://grandtextauto.org/2003/06/17, accessed 8 May 2009.
12 Alan Turing, "Computing Machinery and Intelligence," *Mind* 59 (1959), pp. 233–60.
13 Christiane Paul, *Digital Art* (London and New York: Thames and Hudson, 2003), p. 7.
14 Lev Manovich, *The Language of New Media* (Cambridge: MIT Press, 2001), p. 20.
15 Jay David Bolter and Richard Grusin, *Remediation: Understanding New Media* (Cambridge: MIT Press, 2000), p. 45.
16 Jay David Bolter and Diane Gromala, *Windows and Mirrors: Interaction Design, Digital Art, and the Myth of Transparency* (Cambridge: MIT Press, 2003), p. 15.
17 Kendall Walton, "Categories of Art," *Philosophical Review* 79 (1970), pp. 334–67.
18 See for yourself at http://apoca.mentalpaint.net.

2 A computer art form

1 Randall Packer quoted in Ken Goldberg, The Telegarden Website (n.d.) http://www.ieor.berkeley.edu/~goldberg/garden/Ars, accessed 8 May 2009.
2 For example, David Rokeby, "Transforming Mirrors: Subjectivity and Control in Interactive Media," in *Critical Issues in Interactive Media*, ed. Simon Penny (Albany: SUNY Press, 1995), pp. 144–5; Jim Campbell, "Delusions of Dialogue: Choice and Control in Interactive Art," *Leonardo* 33 (2000), p. 134.
3 Oliver Grau, *Virtual Art: From Illusion to Immersion*, trans. Gloria Custance (Cambridge: MIT Press, 2003).
4 Ibid., p. 304.
5 Clement Greenberg, "Avant-Garde and Kitsch," in *Art and Culture* (Boston: Beacon, 1961), p. 7.
6 See also Manovich, *Language of New Media*, pp. 207–11; Grau, *Virtual Reality*, pp. 127 and 203–7; and Theodor Adorno, "Culture Industry Reconsidered," in *The Culture Industry*, ed. J. M. Bernstein (London: Routledge, 1991), pp. 64, 101.
7 Hal Foster, *Design and Crime* (London: Verso, 2002), p. 98.
8 Greenberg, "Avant-Garde and Kitsch"; Max Horkheimer and Theodor Adorno, "The Culture Industry," in *Dialectic of Enlightenment*, trans. John Cumming (New York: Herder and Herder, 1972); and Adorno, "Culture Industry Reconsidered." For a meticulous analysis, see Noël Carroll, *Philosophy of Mass Art*, pp. 15–89.
9 Horkheimer and Adorno, "Culture Industry," pp. 126–7.
10 Grau, *Virtual Art*, pp. 127 and 202.
11 Aby Warburg, *Der Bilderatlas Mnemosyne*, eds Martin Warnke and Claudia Brink (Berlin: Akademie Verlag, 2000), p. 3.
12 Grau, *Virtual Art*, p. 202, see also pp. 111, 199, 202, 216.
13 Paul Virilio, "Speed and Information: Cyberspace Alarm!" ctheory.net, eds Arthur Kroker and Marilouise Kroker (1975), http://www.ctheory.net/articles.aspx?id=72, accessed 8 May 2009.
14 Horkheimer and Adorno, "The Culture Industry," pp. 126, 144.
15 Jean Baudrillard, *The Transparency of Evil*, trans. James Benedict (London: Verso, 1993), p. 51.

16 Lev Manovich, "From the Externalization of the Psyche to the Implantation of Technology," in *Mind Revolution: Interface Brain/Computer*, ed. Florian Rötzer (Munich: Akademie zum dritten Jahrtausend, 1995), pp. 90–100. See also Manovich, *Language of New Media*, pp. 60–1.

17 Lev Manovich, "On Totalitarian Interactivity" (n.d.), http://www.manovich.net/TEXT/totalitarian.html, accessed 8 May 2009.

18 Ibid.

19 Adorno, "Culture Industry Reconsidered," p. 106.

3 Live wires: computing interaction

1 S. Damarin cited in Roderick Sims, "Interactivity: A Forgotten Art?" *Computers in Human Behavior* 13 (1997), p. 159; and Greg Costikyan, "I Have No Words and I Must Design," *Interactive Fantasy* 2 (1994), http://www.costik.com/nowords.html, accessed 8 May 2009.

2 For example, Erving Goffman, *Interaction Ritual: Essays on Face-to-Face Behavior* (New York: Doubleday, 1967).

3 Michael Hammel, "Towards a Yet Newer Laocoon, Or, What We Can Learn from Interacting with Computer Games," in *Digital Art History: A Subject in Transition*, eds Anna Bentkowska-Kafel, Trish Cashen, and Hazel Gardiner (Bristol: Intellect, 2005), p. 58.

4 Quoted in Octavio Paz, *Marcel Duchamp, or the Castle of Purity*, trans. Donald Gardner (New York: Viking, 1978), p. 85.

5 David Novitz, "Participatory Art and Appreciative Practice," *British Journal of Aesthetics* 59 (2001), pp. 153–65.

6 Manovich, *Language of New Media*, p. 56; see also Rokeby, "Transforming Mirrors," p. 134; Paul, *Digital Art*, p. 67; and Claire Bishop, "Antagonism and Relational Aesthetics," *October* 110 (2004), p. 62.

7 Umberto Eco, *The Open Work*, trans. Anna Cangoni (Cambridge: Harvard University Press, 1989), pp. 1–4, 12; Roy Ascott, "Behaviourist Art and the Cybernetic Vision," in *Telematic Embrace: Visionary Theories of Art, Technology, and Consciousness*, ed. Edward Shanken (Berkeley: University of California Press, 2003), p. 111; Stroud Cornock and Ernest Edmonds, "The Creative Process Where the Artist is Amplified or Superseded by the Computer," *Leonardo* 6 (1973), p. 13; Myron Krueger, *Artificial Reality II* (Reading: Addison-Wesley, 1991), pp. xii–xiii; Timothy Binkley, "The Vitality of Digital Creation," *Journal of Aesthetics and Art Criticism* 55 (1997), p. 114; and David Saltz, "The Art of Interaction: Interactivity, Performativity, and Computers," *Journal of Aesthetics and Art Criticism* 55 (1997), pp. 118–19.

8 Bolter and Gromala, *Windows and Mirrors*, pp. 22, 147.

9 For example, Stephen Wilson, *Information Arts: Intersections of Art, Science, and Technology* (Cambridge: MIT Press, 2003), p. 655.

10 This conception was formalized in Alan Turing, "On Computable Numbers, with an Application to the *Entscheidungsproblem*," *Proceedings of the London Mathematical Society* Series 2, 42 (1936), pp. 230–65.

11 Allan Kaprow, "'Happenings' in the New York Scene," in *The New Media Reader*, eds Noah Wardrip-Fruin and Nick Montfort (Cambridge: MIT Press, 2003), pp. 84–6.

12 Augusto Boal, "Theater of the Oppressed," in *New Media Reader*, pp. 343–52.
13 Tiravanija's work is a model of interactivity in Nicolas Bourriaud, *Relational Aesthetics*, trans. Simon Pleasance, Fronza Woods, and Mathieu Copeland (Dijon: Les Presses du Réel, 2002).
14 B. Jack Copeland, "Computation," in *The Blackwell Guide to Computing and Information*, ed. Luciano Floridi (Oxford: Blackwell, 2004), pp. 3–17.
15 Turing, "On Computable Numbers."

4 Work to rule

1 Damian Lopes, "Writing: Project X 1497–1999" (2006), http://damianlopes.com/projectx.
2 Not all – see Stephen Davies, *Musical Works and Performances* (Oxford: Oxford University Press, 2001), pp. 25–34.
3 Nicholas Wolterstorff, *Works and Worlds of Art* (Oxford: Oxford University Press, 1980), p. 41.
4 Davies, *Musical Works and Performances*.
5 James O. Young and Carl Matheson, "The Metaphysics of Jazz," *Journal of Aesthetics and Art Criticism* 58 (2000), pp. 125–33.
6 Bolter, *Writing Space*, p. 127.
7 Lopes, "Writing: Project X 1497–1999."
8 Risto Hilpinen, "On Artifacts and Works of Art," *Theoria* 58 (1992), pp. 58–82.
9 Dominic McIver Lopes, "The Ontology of Interactive Art," *Journal of Aesthetic Education* 35.4 (2001), pp. 65–81.
10 Clement Greenberg, "Towards a Newer Laocoön," *Partisan Review* 7 (1940), pp. 296–310.
11 Nan Stalnaker, "Fakes and Forgeries," in *Routledge Companion to Aesthetics*, 2nd edn, eds Berys Gaut and Dominic McIver Lopes (London: Routledge, 2005), pp. 514–25.
12 Jerrold Levinson, "What a Musical Work Is," *Journal of Philosophy* 77 (1980), pp. 5–28.
13 Sherri Irvin, "The Artist's Sanction in Contemporary Art," *Journal of Aesthetics and Art Criticism* 63 (2005), pp. 315–26.

5 Artist to audience

1 Richard Kostelanetz, *Conversing with Cage* (New York: Limelight, 1988), p. 74.
2 Hammel, "Towards a Yet Newer Laocoon," p. 63.
3 Rokeby, "Transforming Mirrors," p. 143.
4 Krueger, *Artificial Reality II*, pp. xii–xiii.
5 Roy Ascott, "Is There Love in the Telematic Embrace?" in *Telematic Embrace*, p. 238.
6 Levy, "The Art of Cyberspace," pp. 366–7.
7 Gary Iseminger, *The Aesthetic Function of Art* (Ithaca: Cornell University Press, 2004), p. 32.

8 Daniel Levitin, *This Is Your Brain on Music: The Science of a Human Obsession* (New York: Dutton, 2006), pp. 6–7.

9 Richard Wollheim, *Painting as an Art* (London and New York: Thames and Hudson, 1987), chs 1–2; and George Dickie, *The Art Circle* (Chicago: Spectrum, 1997).

10 Hilpinen, "On Artifacts and Works of Art," pp. 58–82.

11 Carroll, *A Philosophy of Mass Art*, pp. 211–22.

12 For example, Roland Barthes, "The Death of the Author," in *Image, Music, Text*, trans. Stephen Heath (New York: Hill and Wang, 1977).

13 Hilpinen, "On Artifacts and Works of Art," p. 78.

14 Rush, *New Media in Late 20th-century Art*, p. 216.

15 Boal, "Theater of the Oppressed," p. 352.

16 Rainer Linz, "Interactive Music Performance" (2003), http://www.rainerlinz.net/NMA/articles/interactive.html, accessed 8 May 2009.

17 Jenn Neilson, "Interactive Art as Performance," unpublished ms.

18 See also Paul Thom, *For an Audience* (Philadelphia: Temple University Press, 1993), pp. 179–81.

19 Berys Gaut, *A Philosophy of Cinematic Art* (Cambridge: Cambridge University Press, 2009).

20 Kaprow, "'Happenings' in the New York Scene," p. 84.

21 Jean-Jacques Rousseau, *Lettre à d'Alembert* (Paris, 1758).

22 Cf. Lopes, "The Ontology of Interactive Art," pp. 68–70.

23 Bolter and Gromala, *Windows and Mirrors*, pp. 12–13.

24 Rokeby, "Transforming Mirrors," p. 153.

6 Computer art poetics

1 Linda Candy, "Defining Interaction," in *Explorations in Art and Technology*, eds Linda Candy and Ernest Edmonds (London: Springer, 2002), p. 266.

2 For a definition, see Dustin Stokes, "A Metaphysics of Creativity," in *New Waves in Aesthetics*, eds Katherine Thomson-Jones and Kathleen Stock (London: Palgrave Macmillan, 2008), pp. 105–24.

3 Margaret Boden, *The Creative Mind: Myths and Mechanisms* (London: Routledge, 2004), p. 2.

4 For example, David Novitz, "Creativity and Constraint," *Australasian Journal of Philosophy* 77 (1999), pp. 67–82; and Berys Gaut and Paisley Livingston, eds, *The Creation of Art* (Cambridge: Cambridge University Press, 2003).

5 Greenberg, "Avant-Garde and Kitsch."

6 Some may deny it – for example, R. G. Collingwood, *The Principles of Art* (Oxford: Oxford University Press, 1938).

7 Espen Aarseth, "Genre Trouble," Electronic Book Review (2004), http://www.electronicbookreview.com/thread/firstperson/vigilant, accessed 8 May 2009.

8 Krueger, *Artificial Reality II*, pp. xiii, 45.

9 Erkki Huhtamo, "Seeking Deeper Contact: Interactive Art as Metacommentary," *Convergence* 1 (1995), p. 84.

10 Virilio, "Speed and Information."

11 Horkheimer and Adorno, "The Culture Industry," pp. 126–7.

12 Grau, *Virtual Art*, p. 202.

13 Huhtamo, "Seeking Deeper Contact," p. 86.

14 Sherry Turkle, *The Second Self: Computers and the Human Spirit*, 2nd edn (Cambridge: MIT Press, 2005), pp. 65–90.

15 Eco, *Open Work*, p. 4.

16 Manovich, "On Totalitarian Interactivity."

17 Rokeby, "Transforming Mirrors," p. 155.

18 Carroll, *A Philosophy of Mass Art*, p. 196.

19 Ibid., p. 199.

20 "Useless Programs, Useful Programmers, and the Production of Social Interactive Artworks: Interview with Scott Snibbe," *Dichtung-digital: Journal für Digitale Ästhetik* (2006), http://www.dichtung-digital.org/2006/1-Snibbe.htm, accessed 8 May 2009.

21 Brian Reffin-Smith, "Post-modem Art, or: Virtual Reality as Trojan Donkey, or: Horsetail Tartan Literature Groin Art," in *Computers and Art*, ed. Stuart Mealing (Bristol: Intellect Books, 1997), p. 98.

22 Don Ritter, "My Finger's Getting Tired: Unencumbered Interactive Installations for the Entire Body" (2001), http://aesthetic-machinery.com/articles-myfinger.html, accessed 8 May 2009.

23 Margaret Boden, "Aesthetics and Interactive Art," in *Art, Body, Embodiment*, eds Christina Makris, Ron Chrisley, Ron Clowes, and Margaret Boden (Newcastle: Cambridge Scholars Press, forthcoming).

24 Frank Sibley, "General Criteria and Reasons in Aesthetics," in *Approach to Aesthetics*, eds John Benson, Betty Redfern, and Jeremy Roxbee Cox (Oxford: Oxford University Press, 2006), pp. 104–18.

7 Atari to art

1 Henry Jenkins, "Games, The New Lively Art," in *Handbook of Computer Game Studies*, eds Joost Raessens and Jeffrey Goldstein (Cambridge: MIT Press, 2005), p. 176.

2 Mark J. P. Wolf, *The Medium of the Video Game* (Austin: University of Texas Press, 2001), ch. 6.

3 Good definitions of games exist – for example, Jesper Juul, *Half-Real: Video Games Between Real Rules and Fictional Worlds* (Cambridge: MIT Press, 2005), ch. 2.

4 Chris Crawford, *The Art of Computer Game Design* (Berkeley: Osborne/McGraw-Hill, 1984), pp. 7–8; Costickyan, "I Have No Words and I Must Design"; Wolf, *The Medium of the Video Game*, pp. 19, 114; and Katie Salen and Eric Zimmerman, *Rules of Play: Game Design Fundamentals* (Cambridge: MIT Press, 2004), pp. 57–8. The point is implied by Roger Caillois, *Man, Play, and Games*, trans. Meyer Barash (New York: Schocken, 1961); and Juul, *Half-Real*, p. 36.

5 Salen and Zimmerman, *Rules of Play*, p. 58.

6 Alexander R. Galloway, *Gaming: Essays on Algorithmic Culture* (Minneapolis: University of Minnesota Press, 2006), p. 3.

7 Crawford, *The Art of Computer Game Design*; Wolf, *The Medium of the Video Game*; Juul, *Half-Real*, p. viii.

8 For example, Janet H. Murray, *Hamlet on the Holodeck: The Future of Narrative in Cyberspace* (Cambridge: MIT Press, 1998).

9 Richard Wollheim, "Why Is Drawing Interesting?" *British Journal of Aesthetics* 45 (2005), p. 5.

10 Ibid.

11 Berys Gaut, "'Art' as a Cluster Concept," in *Theories of Art Today*, ed. Noël Carroll (Madison: University of Wisconsin Press, 2000), p. 28. See also Denis Dutton, "A Naturalist Definition of Art," *Journal of Aesthetics and Art Criticism* 64 (2006), pp. 367–77.

12 Monroe Beardsley, "In Defense of Aesthetic Value," *Proceedings and Addresses of the American Philosophical Association* 52 (1979), p. 729.

13 For example, Leo Tolstoy, *What Is Art?* trans. Aylmer Maude (Oxford: Oxford University Press, 1962); and Clive Bell, *Art* (London: Chatto and Windus, 1914).

14 George Dickie, *Art and the Aesthetic* (Ithaca: Cornell University Press, 1974).

15 "Useless Programs, Useful Programmers, and the Production of Social Interactive Artwork."

16 Ibid.

17 Anne-Marie Schleiner, "Game Reconstruction Workshop: Demolishing and Evolving PC Games and Gamer Culture," in *Handbook of Computer Game Studies*, pp. 405–14; and Galloway, *Gaming*, ch. 5.

18 Rochelle Slovin, "Hot Circuits: Reflections on the 1989 Video Game Exhibition of the American Museum of the Moving Image," in *The Medium of the Video Game*, pp. 137–54.

19 For example, John Seabrook, "Game Master," *The New Yorker* (November 6, 2006).

20 Markku Eskelinen and Ragnhild Tronstad, "Video Games and Configurative Performances," in *The Video Game Theory Reader*, eds Mark J. P. Wolf and Bernard Perron (London: Routledge, 2003), p. 197.

21 Aaron Smuts, "Are Video Games Art?" *Contemporary Aesthetics* 3 (2005), http://www.contempaesthetics.org, accessed 8 May 2009.

22 Noël Carroll, *The Philosophy of Horror: or, Paradoxes of the Heart* (London: Routledge, 1990).

23 *American Amusement Machine Association v. Kendrick*, 244 F.3d 572, 577-79 (7th Cir. 2001).

24 See Grant Tavinor, "Videogames and Interactive Fiction," *Philosophy and Literature* 29 (2005), pp. 24–40.

25 Quoted in Kendra Mayfield, "Once It Was Atari, Now It's Art," *Wired* (July 2001), http://www.wired.com/culture/lifestyle/news/2001/07/45146, accessed 8 May 2009.

26 Aarseth, "Genre Trouble."

27 Crawford, *The Art of Computer Game Design*, p. xii.

28 Steven Poole, *Trigger Happy: Videogames and the Entertainment Revolution* (London: Fourth Estate, 2000), p. 226.

29 Andrew Darley, *Visual Digital Culture: Surface Play and Spectacle in New Media Genres* (London: Routledge, 2000), pp. 163–9.

30 Quoted in Seabrook, "Game Master."

31 Christopher Alexander, Sara Ishikawa, and Murray Silverstein, *A Pattern Language: Towns, Buildings, Construction* (New York: Oxford University Press, 1977); Abraham H. Maslow, "A Theory of Human Motivation," *Psychological Review* 50 (1943), pp. 370–96.

32 A cost that some accept. For example, Collingwood, *Principles of Art*.
33 Hammel, "Towards a Yet Newer Laocoon," p. 59.
34 Samuel Taylor Coleridge, *Seven Lectures on Shakespeare and Milton* (London: Chapman and Hall, 1856), p. 3.

Envoi

1 John A. Fisher, "High Art vs Low Art," in *Routledge Companion to Aesthetics*, 2nd edn, eds Berys Gaut and Dominic McIver Lopes (London: Routledge, 2005), pp. 527–40.
2 Bolter, *Writing Space*, p. 130.
3 Kendall Walton, *Mimesis as Make-believe* (Cambridge: Harvard University Press, 1990).
4 Brian Laetz and Dominic McIver Lopes, "Genre," in *The Routledge Companion to Film and Philosophy*, eds Paisley Livingston and Carl Plantinga (London: Routledge, 2008), pp. 152–61.

BIBLIOGRAPHY

Aarseth, Espen, "Genre Trouble," Electronic Book Review (2004), http://www.electronicbookreview.com/thread/firstperson/vigilant.

Adorno, Theodor, "Culture Industry Reconsidered," in *The Culture Industry*, ed. J. M. Bernstein (London: Routledge, 1991), pp. 98–106.

Alexander, Christopher, Sara Ishikawa, and Murray Silverstein, *A Pattern Language: Towns, Buildings, Construction* (New York: Oxford University Press, 1977).

American Amusement Machine Association v. Kendrick, 244 F.3d 572, 577-79 (7th Cir. 2001).

Ascott, Roy, "Behaviourist Art and the Cybernetic Vision," in *Telematic Embrace: Visionary Theories of Art, Technology, and Consciousness*, ed. Edward Shanken (Berkeley: University of California Press, 2003), pp. 109–56.

—— "Is There Love in the Telematic Embrace?" in *Telematic Embrace: Visionary Theories of Art, Technology, and Consciousness*, ed. Edward Shanken (Berkeley: University of California Press, 2003), pp. 232–46.

Barthes, Roland, "The Death of the Author," in *Image, Music, Text*, trans. Stephen Heath (New York: Hill and Wang, 1977), pp. 142–8.

Baudrillard, Jean, *The Transparency of Evil*, trans. James Benedict (London: Verso, 1993).

Beardsley, Monroe, "In Defense of Aesthetic Value," *Proceedings and Addresses of the American Philosophical Association* 52 (1979), pp. 723–49.

Bell, Clive, *Art* (London: Chatto and Windus, 1914).

Binkley, Timothy, "The Vitality of Digital Creation," *Journal of Aesthetics and Art Criticism* 55 (1997), pp. 107–16.

Bishop, Claire, "Antagonism and Relational Aesthetics," *October* 110 (2004), pp. 51–79.

Boal, Augusto, "Theater of the Oppressed," in *The New Media Reader*, eds Noah Wardrip-Fruin and Nick Montfort (Cambridge: MIT Press, 2003), pp. 343–52.

Boden, Margaret, "Aesthetics and Interactive Art," in *Art, Body, Embodiment*, eds Christina Makris, Ron Chrisley, Ron Clowes, and Margaret Boden (Newcastle: Cambridge Scholars Press, forthcoming).

—— *The Creative Mind: Myths and Mechanisms* (London: Routledge, 2004).

Bolter, Jay David, *Writing Space: Computers, Hypertext, and the Remediation of Print* (Mahwah, NJ: Lawrence Erlbaum, 2001).

Bolter, Jay David and Diane Gromala, *Windows and Mirrors: Interaction Design, Digital Art, and the Myth of Transparency* (Cambridge: MIT Press, 2003).

Bolter, Jay David and Richard Grusin, *Remediation: Understanding New Media* (Cambridge: MIT Press, 2000).

Bourriaud, Nicolas, *Relational Aesthetics*, trans. Simon Pleasance, Fronza Woods, and Mathieu Copeland (Dijon: Les Presses du Réel, 2002).

Business Wire, "Dassault Systemes and IBM Sponsor Frank Gehry, Architect, at the Solomon R. Guggenheim Museum in New York City," (May 16, 2001).

Caillois, Roger, *Man, Play, and Games*, trans. Meyer Barash (New York: Schocken, 1961).

Campbell, Jim, "Delusions of Dialogue: Choice and Control in Interactive Art," *Leonardo* 33 (2000), pp. 133–6.

Candy, Linda, "Defining Interaction," in *Explorations in Art and Technology*, eds Linda Candy and Ernest Edmonds (London: Springer, 2002), pp. 261–6.

Carroll, Noël, *A Philosophy of Mass Art* (Oxford: Oxford University Press, 1998).

—— *The Philosophy of Horror: or, Paradoxes of the Heart* (London: Routledge, 1990).

Cohen, Harold, "The Further Exploits of AARON, Painter," *Stanford Humanities Review* 4 (1995), pp. 141–58.

Coleridge, Samuel Taylor, *Seven Lectures on Shakespeare and Milton* (London: Chapman and Hall, 1856).

Collingwood, R. G., *The Principles of Art* (Oxford: Oxford University Press, 1938).

Cope, David, *Computer Models of Musical Creativity* (Cambridge: MIT Press, 2005).

Copeland, B. Jack, "Computation," in *The Blackwell Guide to Computing and Information*, ed. Luciano Floridi (Oxford: Blackwell, 2004), pp. 3–17.

Cornock, Stroud and Ernest Edmonds, "The Creative Process Where the Artist is Amplified or Superseded by the Computer," *Leonardo* 6 (1973), pp. 11–15.

Costikyan, Greg, "I Have No Words and I Must Design," *Interactive Fantasy* 2 (1994), http://www.costik.com/nowords.html.

Crawford, Chris, *The Art of Computer Game Design* (Berkeley: Osborne/McGraw-Hill, 1984).

Darley, Andrew, *Visual Digital Culture: Surface Play and Spectacle in New Media Genres* (London: Routledge, 2000).

Davies, Stephen, *Musical Works and Performances* (Oxford: Oxford University Press, 2001).

Dickie, George, *Art and the Aesthetic* (Ithaca: Cornell University Press, 1974).

—— *The Art Circle* (Chicago: Spectrum, 1997).

Dutton, Denis, "A Naturalist Definition of Art," *Journal of Aesthetics and Art Criticism* 64 (2006), pp. 367–77.

Eco, Umberto, *The Open Work*, trans. Anna Cangoni (Cambridge: Harvard University Press, 1989).

Eskelinen, Markku and Ragnhild Tronstad, "Video Games and Configurative Performances," in *The Video Game Theory Reader*, eds Mark J. P. Wolf and Bernard Perron (London: Routledge, 2003), pp. 195–220.

Fisher, John A., "High Art vs Low Art," in *Routledge Companion to Aesthetics*, 2nd edn, eds Berys Gaut and Dominic McIver Lopes (London: Routledge, 2005), pp. 527–40.

Foster, Hal, *Design and Crime* (London: Verso, 2002).

Galloway, Alexander R., *Gaming: Essays on Algorithmic Culture* (Minneapolis: University of Minnesota Press, 2006).

Gaut, Berys, *A Philosophy of Cinematic Art* (Cambridge: Cambridge University Press, 2009).

—— "'Art' as a Cluster Concept," in *Theories of Art Today*, ed. Noël Carroll (Madison: University of Wisconsin Press, 2000), pp. 25–44.

Gaut, Berys and Paisley Livingston, eds, *The Creation of Art* (Cambridge: Cambridge University Press, 2003).

Goffman, Erving, *Interaction Ritual: Essays on Face-to-Face Behavior* (New York: Doubleday, 1967).

Grau, Oliver, *Virtual Art: From Illusion to Immersion*, trans. Gloria Custance (Cambridge: MIT Press, 2003).

Greenberg, Clement, "Avant-Garde and Kitsch," in *Art and Culture* (Boston: Beacon, 1961), pp. 3–21.

—— "Towards a Newer Laocoön," *Partisan Review* 7 (1940), pp. 296–310.

Hammel, Michael, "Towards a Yet Newer Laocoon, Or, What We Can Learn from Interacting with Computer Games," in *Digital Art History: A Subject in Transition*, eds Anna Bentkowska-Kafel, Trish Cashen, and Hazel Gardiner (Bristol: Intellect, 2005), pp. 57–64.

Heffernan, Virginia, "Sepia No More," *New York Times Magazine* (April 27, 2008), pp. 18–19.

Hilpinen, Risto, "On Artifacts and Works of Art," *Theoria* 58 (1992), pp. 58–82.

Horkheimer, Max and Theodor Adorno, "The Culture Industry," in *Dialectic of Enlightenment*, trans. John Cumming (New York: Herder and Herder, 1972), pp. 94–136.

Huhtamo, Erkki, "Seeking Deeper Contact: Interactive Art as Metacommentary," *Convergence* 1 (1995), pp. 81–104.

Irvin, Sherri, "The Artist's Sanction in Contemporary Art," *Journal of Aesthetics and Art Criticism* 63 (2005), pp. 315–26.

Iseminger, Gary, *The Aesthetic Function of Art* (Ithaca: Cornell University Press, 2004).

Jenkins, Henry, "Games, The New Lively Art," in *Handbook of Computer Game Studies*, eds Joost Raessens and Jeffrey Goldstein (Cambridge: MIT Press, 2005), pp. 175–92.

Juul, Jesper, *Half-Real: Video Games Between Real Rules and Fictional Worlds* (Cambridge: MIT Press, 2005).

Kaprow, Allan, "'Happenings' in the New York Scene," in *The New Media Reader*, eds Noah Wardrip-Fruin and Nick Montfort (Cambridge: MIT Press, 2003), pp. 84–6.

Kostelanetz, Richard, *Conversing with Cage* (New York: Limelight, 1988).

Krueger, Myron, *Artificial Reality II* (Reading: Addison-Wesley, 1991).

Laetz, Brian and Dominic McIver Lopes, "Genre," in *The Routledge Companion to Film and Philosophy*, eds Paisley Livingston and Carl Plantinga (London: Routledge, 2008), pp. 152–61.

Levinson, Jerrold, "What a Musical Work Is," *Journal of Philosophy* 77 (1980), pp. 5–28.

Levitin, Daniel, *This Is Your Brain on Music: The Science of a Human Obsession* (New York: Dutton, 2006).

Levy, Pierre, "The Art of Cyberspace," in *Electronic Cultures: Technology and Representation*, ed. Timothy Druckrey (New York: Aperture, 1996), pp. 366–7.

Linz, Rainer, "Interactive Music Performance" (2003), http://www.rainerlinz.net/NMA/articles/interactive.html.

Lopes, Damian, "Writing: Project X 1497–1999" (2006), http://damianlopes.com/projectx.

Lopes, Dominic McIver, "The Ontology of Interactive Art," *Journal of Aesthetic Education* 35.4 (2001), pp. 65–81.

Manovich, Lev, "From the Externalization of the Psyche to the Implantation of Technology," in *Mind Revolution: Interface Brain/Computer*, ed. Florian Rötzer (Munich: Akademie zum dritten Jahrtausend, 1995), pp. 90–100.

—— "On Totalitarian Interactivity" (n.d.), http://www.manovich.net/TEXT/totalitarian.html.

—— *The Language of New Media* (Cambridge: MIT Press, 2001).

Maslow, Abraham H., "A Theory of Human Motivation," *Psychological Review* 50 (1943), pp. 370–96.

Mayfield, Kendra, "Once It Was Atari, Now It's Art," *Wired* (July 2001), http://www.wired.com/culture/lifestyle/news/2001/07/45146.

Mitchell, William J., *The Reconfigured Eye: Visual Truth in the Post-Photographic Era* (Cambridge: MIT Press, 1992).

Murray, Janet H., *Hamlet on the Holodeck: The Future of Narrative in Cyberspace* (Cambridge: MIT Press, 1998).

Neilson, Jenn, "Interactive Art as Performance," unpublished ms.

Novitz, David, "Creativity and Constraint," *Australasian Journal of Philosophy* 77 (1999), pp. 67–82.

—— "Participatory Art and Appreciative Practice," *British Journal of Aesthetics* 59 (2001), pp. 153–65.

Parkinson, G. H. R., "The Cybernetic Approach to Aesthetics," *Philosophy* 36 (1961), pp. 49–61.

Paul, Christiane, *Digital Art* (London and New York: Thames and Hudson, 2003).

Paz, Octavio, *Marcel Duchamp, Or the Castle of Purity*, trans. Donald Gardner (New York: Viking, 1978).

Poole, Steven, *Trigger Happy: Videogames and the Entertainment Revolution* (London: Fourth Estate, 2000).

Reffin-Smith, Brian, "Post-modem Art, or: Virtual Reality as Trojan Donkey, or: Horsetail Tartan Literature Groin Art," in *Computers and Art*, ed. Stuart Mealing (Bristol: Intellect Books, 1997), pp. 97–117.

Ritter, Don, "My Finger's Getting Tired: Unencumbered Interactive Installations for the Entire Body" (2001), http://aesthetic-machinery.com/articles-myfinger.html.

Rokeby, David, "Transforming Mirrors: Subjectivity and Control in Interactive Media," in *Critical Issues in Interactive Media*, ed. Simon Penny (Albany: SUNY Press, 1995), pp. 132–58.

Rousseau, Jean-Jacques, *Lettre à d'Alembert* (Paris, 1758)

Rush, Michael, *New Media in Late 20th-century Art* (London and New York: Thames and Hudson, 1999).

Salen, Katie and Eric Zimmerman, *Rules of Play: Game Design Fundamentals* (Cambridge: MIT Press, 2004).

Saltz, David, "The Art of Interaction: Interactivity, Performativity, and Computers," *Journal of Aesthetics and Art Criticism* 55 (1997), pp. 117–27.

Schleiner, Anne-Marie, "Game Reconstruction Workshop: Demolishing and Evolving PC Games and Gamer Culture," in *Handbook of Computer Game Studies*, eds Joost Raessens and Jeffrey Goldstein (Cambridge: MIT Press, 2005), pp. 405–14.

Seabrook, John, "Game Master," *The New Yorker* (November 6, 2006).

Sibley, Frank, "General Criteria and Reasons in Aesthetics," in *Approach to Aesthetics*, eds John Benson, Betty Redfern, and Jeremy Roxbee Cox (Oxford: Oxford University Press, 2006), pp. 104–18.

Sims, Roderick, "Interactivity: A Forgotten Art?" *Computers in Human Behavior* 13 (1997), pp. 157–80.

Slovin, Rochelle, "Hot Circuits: Reflections on the 1989 Video Game Exhibition of the American Museum of the Moving Image," in *The Medium of the Video Game* (Austin: University of Texas Press, 2001), pp. 137–54.

Smuts, Aaron, "Are Video Games Art?" *Contemporary Aesthetics* 3 (2005), http://www.contempaesthetics.org.

Snibbe, Scott "Useless Programs, Useful Programmers, and the Production of Social Interactive Artworks," Interviewed by Roberto Simanowski, *Dichtung-digital: Journal für Digitale Ästhetik* (2006), http://www.dichtung-digital.org/2006/1-Snibbe.htm.

Stalnaker, Nan, "Fakes and Forgeries," in *Routledge Companion to Aesthetics*, 2nd edn, eds Berys Gaut and Dominic McIver Lopes (London: Routledge, 2005), pp. 514–25.

Stern, Andrew, "Harold Cohen on Artist Programmers," Grand Text Auto (June 17, 2003), http://grandtextauto.org/2003/06/17.

Stokes, Dustin, "A Metaphysics of Creativity," in *New Waves in Aesthetics*, eds Katherine Thomson-Jones and Kathleen Stock (London: Palgrave Macmillan, 2008), pp. 105–24.

Tavinor, Grant, "Videogames and Interactive Fiction," *Philosophy and Literature* 29 (2005), pp. 24–40.

Thom, Paul, *For an Audience* (Philadelphia: Temple University Press, 1993).

Tolstoy, Leo, *What Is Art?* trans. Aylmer Maude (Oxford: Oxford University Press, 1962).

Tribe, Mark and Reena Jana, *New Media Art*, ed. Uta Grosenick (Köln: Taschen, 2006).

Turing, Alan, "Computing Machinery and Intelligence," *Mind* 59 (1959), pp. 233–60.

—— "On Computable Numbers, With an Application to the *Entscheidungs-problem*," *Proceedings of the London Mathematical Society*, Series 2, 42 (1936), pp. 230–65.

Turkle, Sherry, *The Second Self: Computers and the Human Spirit*, 2nd edn (Cambridge: MIT Press, 2005).

Virilio, Paul, "Speed and Information: Cyberspace Alarm!" ctheory.net, eds Arthur Kroker and Marilouise Kroker (1975), http://www.ctheory.net/articles.aspx?id=72.

Walton, Kendall, "Categories of Art," *Philosophical Review* 79 (1970), pp. 334–67.

—— *Mimesis as Make-believe* (Cambridge: Harvard University Press, 1990).

Warburg, Aby, *Der Bilderatlas Mnemosyne*, eds Martin Warnke and Claudia Brink (Berlin: Akademie Verlag, 2000).

Wilson, Stephen, *Information Arts: Intersections of Art, Science, and Technology* (Cambridge: MIT Press, 2003).

Wolf, Mark J. P., *The Medium of the Video Game* (Austin: University of Texas Press, 2001).

Wollheim, Richard, *Art and Its Objects*, 2nd edn (Cambridge: Cambridge University Press, 1980).

—— *Painting as an Art* (London and New York: Thames and Hudson, 1987).

—— "Why Is Drawing Interesting?" *British Journal of Aesthetics* 45 (2005), pp. 1–10.

Wolterstorff, Nicholas, *Works and Worlds of Art* (Oxford: Oxford University Press, 1980).

Young, James O. and Carl Matheson, "The Metaphysics of Jazz," *Journal of Aesthetics and Art Criticism* 58 (2000), pp. 125–33.

INDEX